POLITICS
in
art

Fine Art Books for Young People

AMERICAN HISTORY *in Art*
The BIRD *in Art*
The BLACK MAN *in Art*
The CAT *in Art*
CIRCUSES *and* FAIRS *in Art*
The CITY *in Art*
DEMONS *and* BEASTS *in Art*
FARMS *and* FARMERS *in Art*
The HORSE *in Art*
KINGS *and* QUEENS *in Art*
MEDICINE *in Art*
MUSICAL INSTRUMENTS *in Art*
POLITICS *in Art*
The RED MAN *in Art*
The SELF-PORTRAIT *in Art*
The SHIP *and the* SEA *in Art*
SPORTS *and* GAMES *in Art*
The WARRIOR *in Art*
The WORKER *in Art*
The OLD TESTAMENT *in Art*
The NEW TESTAMENT *in Art*

We specialize in producing quality books for young people. For a complete list please write

LERNER PUBLICATIONS COMPANY

241 First Avenue North, Minneapolis, Minnesota 55401

POLITICS
in
art

By Joan Adams Mondale. Designed by Vicki Hall ■ Lerner Publications Company, Minneapolis, Minn.

Second Printing 1974

Verdict of the People (c. 1854) by George Caleb Bingham (1811-1879); The Boatmen's National Bank of St. Louis.

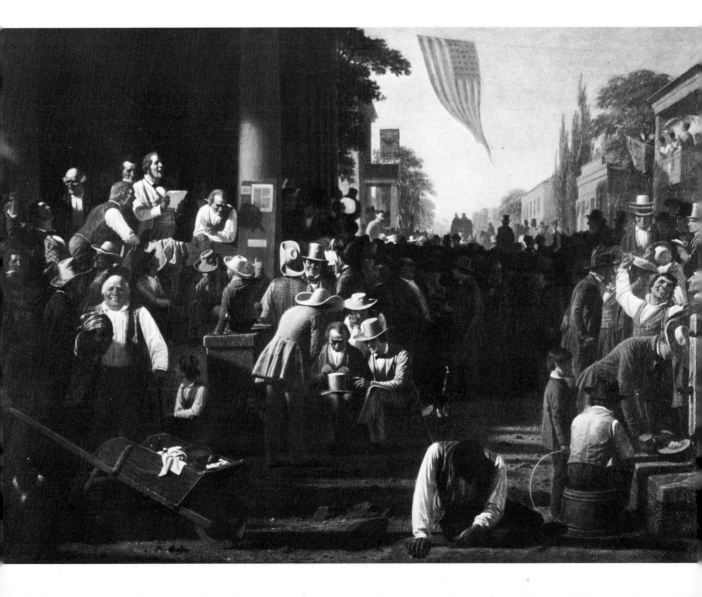

Contents

6

Introduction

Politics is everybody's business. Every citizen should participate in our democracy if we are to have self-government. Each person who is eligible should register and vote. Everyone should make an effort to inform himself about the issues, support the party of his choice, and write to his elected officials.

Sometimes we do not realize how important our participation in politics is. Often we need to be reminded of our duty as citizens. Artists can do just that; they can look at our politicians, our institutions, and our problems to help us understand them better. Artists can reveal the truth about ourselves in powerful and compelling ways. And when they do this, they can spur us into action.

There is a close relationship between the concerns of the artist and those of the politician. Both deal with human emotions and human conditions. Both seek to tell us about the good and the bad in the world around us. Many times the artist is found commenting on the same conditions of social outrage and human failure that the politician is seeking to correct.

Most of the artists in this book have a social conscience. Many of them have actually participated in political movements by exhibiting their work in response to a specific cause, by joining politically active organizations, or by marching in protest demonstrations. Some of the artists, though not active in political movements, have chosen to paint important social problems and bring them directly to our attention. Other artists, especially contemporary ones, let their messages come out indirectly; they force us to draw our own conclusions about the social implications of their work. A few of the artists in this book did not consciously illustrate a social or political problem, but their work points out a vital human need that is the concern of every responsible politician.

In preparing this book, the author fortunately was able to gain insights into some of the works by discussing them with the artists. She talked personally with artists Leland Fletcher, Herblock, Edward Kienholz, Clayton Pinkerton, Fritz Scholder, and J. Fred Woell. She obtained written responses to her observations about their works from Philip Evergood, William Gropper, Grace Hartigan, Jacob Lawrence, Jack Levine, Gluyas Williams, and Andrew Wyeth.

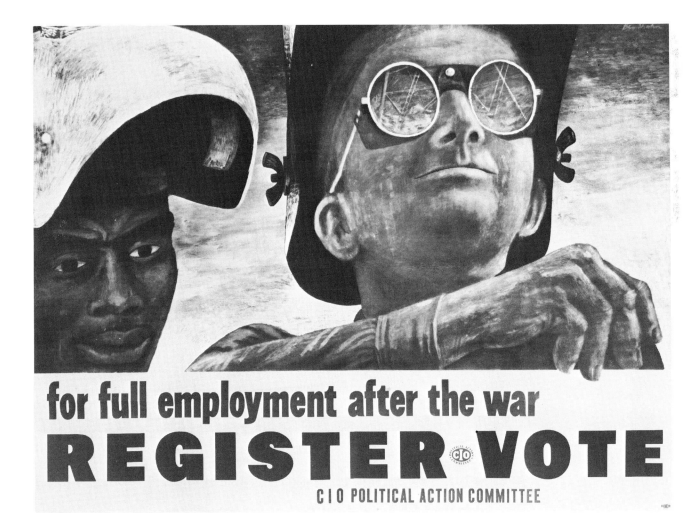

The Welders (1944) by Ben Shahn (1898-1969); Kennedy Galleries, Inc., New York.

Campaigns and Elections

Campaigns and elections are often the most colorful and dramatic aspects of American politics. The campaign provides candidates with an opportunity to explain their positions on issues, and it allows voters to judge those seeking elective office. And on election day, the voter has his turn to speak.

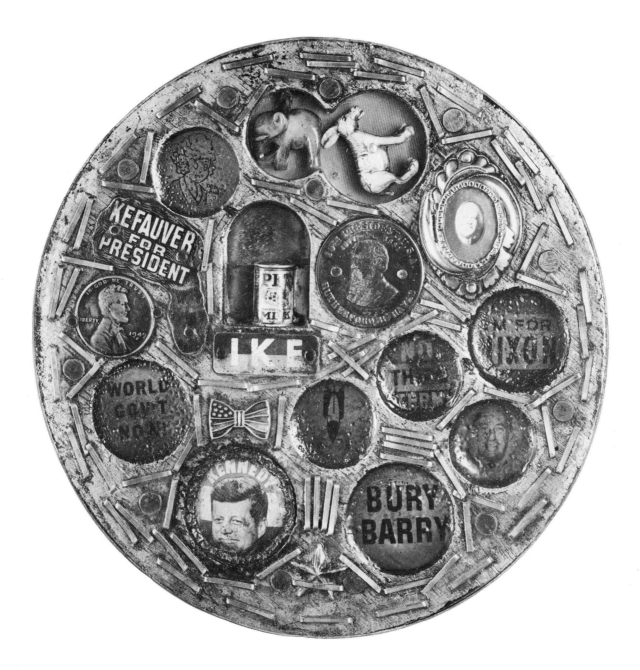

The circle of politics is a whirl of its own, and J. Fred Woell makes it spin in *The Body Politic*, a piece of jewelry made of tin, plastic, copper, wood, and other materials.

Woell is both sculptor and jeweler, and he used both of his skills to make this campaign badge composed of political buttons and other items. It is four inches in diameter and can actually be worn as a badge.

The artist draped a flag above the Kennedy button as a symbol of mourning for the President's assassination. He placed the "Ike" button below a Pet Milk can to say that our country seemed to be contented during the presidency of Dwight D. Eisenhower. "No Third Term" refers to President Franklin D. Roosevelt, who was the only President ever elected to more than two terms.

The cameo in the upper right is the oldest campaign button. Herbert Hoover used it when he ran for the presidency in 1928. Two earlier Presidents also are included—Abraham Lincoln in profile on a penny, and Rutherford B. Hayes on a souvenir coin.

Woell also includes some losers in this work. "Bury Barry" comes from Barry Goldwater's unsuccessful race against Lyndon B. Johnson in 1964, and the Stevenson button is from one of Adlai E. Stevenson's two unsuccessful races against Eisenhower. Estes Kefauver used the coonskin cap button in the presidential primaries. He later became Adlai Stevenson's vice presidential running mate.

"I'm for Nixon" comes from Richard M. Nixon's race against John F. Kennedy in 1960. The button showing a rocket was used to protest nuclear war, and "World Government Now" speaks for itself.

The donkey (Democrat) and the elephant (Republican), of course, represent our two-party system. And what about Little Orphan Annie? The artist says he included it as a joke to show that the body politic also has its moments of absurdity and humor.

The Body Politic (1966) by J. Fred Woell (1934-); collection of the artist, Cambridge, Wisconsin.

Our Republic Is Always "Going to the Dogs" . . . (1880) by Thomas Nast (1840-1902); Harper's Weekly *(May 15, 1880).*

Sometimes an artist, particularly a cartoonist, will take sides in an election and try to influence its outcome. This was true of Thomas Nast, the first great political cartoonist in American history, whose imagination, courage, and artistic skill enabled him to influence public opinion as no previous cartoonist ever had.

In this cartoon, *"Our Republic Is Always 'Going to the Dogs' — According to Those Who Can Not Run It,"* Nast makes fun of Democratic Senator Allen Thurman of Ohio for a speech he made during the 1880 election. Thurman stands atop a stump, waving one arm while speaking earnestly about the terrible condition the country is in. The newspaper which juts from his coat pocket says "out of office," meaning that the Democrats did not occupy the White House. The Senator's theme—"the whole country is Going to the Dogs"—is lettered on a poster mounted behind him, and a partial text of his speech is reprinted on the right.

Instead of an audience of intelligent voters, only a group of weeping dogs is listening to Thurman. And leaning over the fence is Uncle Sam, the American symbol Nast made famous. Uncle Sam has an amused expression on his face; he is enjoying every minute of Nast's joke on the Senator.

Nast's cartoons, suitable for woodblock printing, had great impact because he drew immediately recognizable "portraits" of public figures. These portraits were particularly popular because they were *caricatures*, drawings which emphasize a man's prominent features.

Nast used symbols for ideas that could not be represented by a particular person. He popularized the donkey as a symbol for the Democratic party and created the elephant for the Republican party. Another of Nast's symbols was a wicked tiger, which stood for Tammany Hall, the corrupt political machine that ran New York. Nast's stinging attacks on Tammany Hall's William "Boss" Tweed helped defeat Tammany candidates at the polls and played a major part in putting Tweed in jail.

Thomas Nast began doing cartoons for *Harper's Weekly* magazine in the 1860s. Before that time newspapers and magazines did not carry cartoons regularly. Nast not only made political cartoons popular, but he also turned them into a respected and powerful form of social comment. His cartoons are as sharp and amusing today as they were almost 100 years ago.

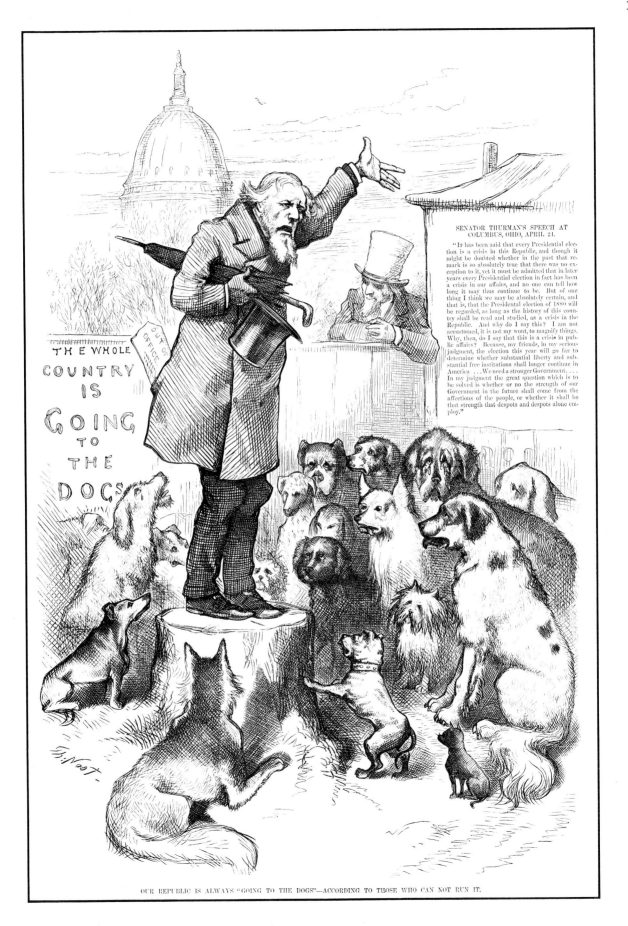

SENATOR THURMAN'S SPEECH AT COLUMBUS, OHIO, APRIL 24.

"It has been said that every Presidential election is a crisis in this Republic, and though it might be doubted whether in the past that remark is so absolutely true that there was no exception to it, yet it must be admitted that in later years every Presidential election in fact has been a crisis in our affairs, and no one can tell how long it may thus continue to be. But of one thing I think we may be absolutely certain, and that is, that the Presidental election of 1880 will be regarded, as long as the history of this country shall be read and studied, as a crisis in the Republic. And why do I say this? I am not accustomed, it is not my wont, to magnify things. Why, then, do I say that this is a crisis in public affairs? Because, my friends, in my serious judgment, the election this year will go far to determine whether substantial liberty and substantial free institutions shall longer continue in America . . . We need a stronger Government. . . . In my judgment the great question which is to be solved is whether or no the strength of our Government in the future shall come from the affections of the people, or whether it shall be that strength that despots and despots alone employ."

THE WHOLE COUNTRY IS GOING TO THE DOGS

OUT OF OFFICE

OUR REPUBLIC IS ALWAYS "GOING TO THE DOGS"—ACCORDING TO THOSE WHO CAN NOT RUN IT.

Political Figures

Many political figures have been portrayed by American artists. Some artists have treated political figures with sympathy, but others have been critical of them. It is logical that the President is the one political figure to receive the most attention from American artists: the presidency is the highest elected office in the United States. The nation looks to the President for leadership and relies heavily on him to solve its problems.

Franklin Delano Roosevelt was the first President to use the press conference as a major way of communicating regularly with the American public. He thus set a precedent his successors could not ignore and made it possible for the presidential press conference to become a national event.

President Roosevelt, also the first Chief Executive to talk to the whole country by radio, was in complete charge at the press conferences held in his office. Gluyas Williams realized this fact and depicted Roosevelt's supreme control in *Press Conference at the White House*, one of several cartoons Williams sketched for the *New Yorker* magazine on a trip to Washington during World War II.

Williams' dry, humorous style was ideally suited to the event he captured. Using black sparingly for the hair and clothing of the reporters, who are bent forward and listening to every word, he created a pattern of shapes pointed toward one focal point—FDR. The President is leaning back in his chair, hands behind him, and smiling confidently.

We do not know, but FDR's confidence may have come from the knowledge that he was about to speak "off the record" as he often did. Or perhaps Roosevelt has just asked that his reply not be directly identified with him, another device he employed. There are no microphones in the sketch, of course, because his press conferences were not broadcast.

This kind of informal press conference still occurs occasionally in the White House, although more often than not the event now takes place on television before the eyes of millions of Americans. It is the latter, the public press conference, that helps fulfill the important need described by literary critic Alfred Kazin:

"The last 40 years have been one continuous crisis and the rest of the century is likely to be more so. Amidst so many earthshaking insecurities, the President of the United States must not only preserve, protect, and defend his fellow Americans, but talk to them as one American to another, and so unite them for the good of the country."*

*Alfred Kazin, "The Prince, American Style," *Vogue*, February 1, 1971.

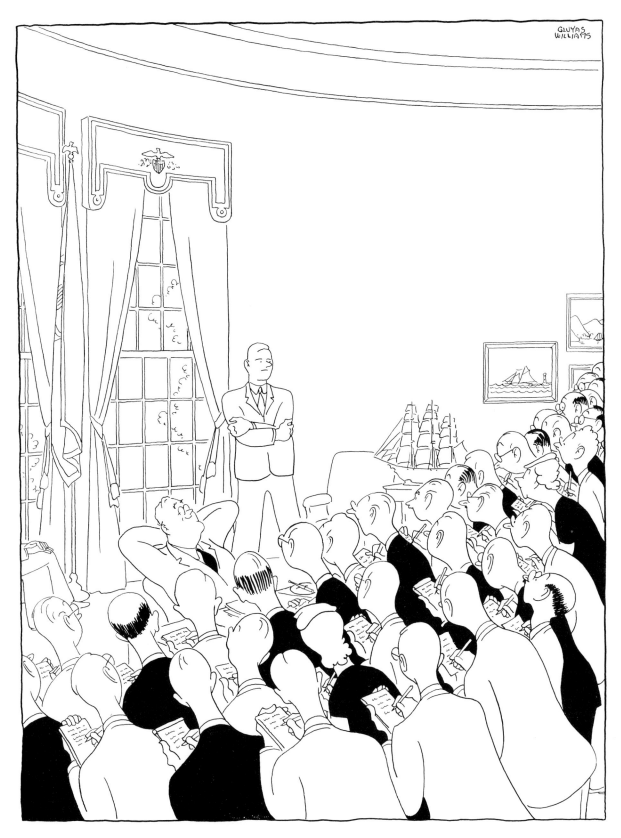

The National Capital: Press Conference at the White House (1942) by Gluyas Williams (1889-); © 1942, 1970 The New Yorker Magazine, Inc.

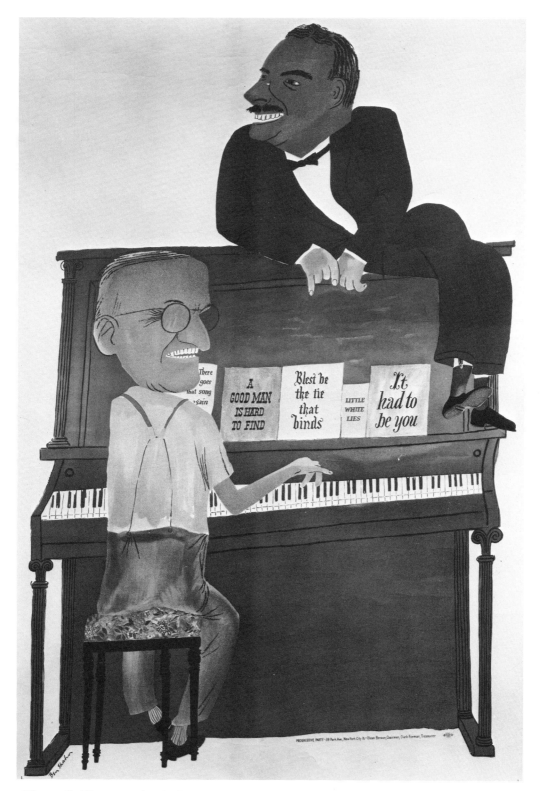

President Harry S. Truman fooled everybody in the election of 1948. Everyone thought that his Republican opponent, New York Governor Thomas E. Dewey, was going to win.

Although Truman was a definite underdog in the election, he campaigned aggressively, traveling the country by train and giving "whistle-stop" speeches from the rear platform of his railroad car.

Truman and Dewey (1948) by Ben Shahn (1898-1969); Kennedy Galleries, Inc., New York.

Truman, who was Vice President under Franklin D. Roosevelt, had become President in 1945 when Roosevelt died. Then the 1946 elections had given the Republicans control of Congress, and they blocked most of Truman's proposed legislation. As he campaigned in 1948, Truman denounced the "do-nothing, good-for-nothing 80th Congress" so vigorously that enthusiastic crowds shouted, "Pour it on, Harry" and "Give it to 'em."

On election night, people expected the final result to be announced shortly after the polls closed. But because the election was so close they had to wait all night long. At least one newspaper printed its headline early, saying "Dewey Defeats Truman." It was not until the next day that the astonishing outcome was reported—Truman had won!

In *Truman and Dewey*, Ben Shahn pictures the two political opponents together as they never would have been in real life. Truman plays the piano while Dewey lounges on top of it, singing Harry's songs. The pose and the music have a double meaning; Truman is literally "calling the tune" for the election.

The sheet music titles in varied type show an interest in printed letters that Shahn revealed in many of his other works. The titles of these well-known songs also tell us that Shahn is making fun of both politicians. Dewey's over-confident smile and Truman's blank eyeglasses are two other clues to the artist's humorous point of view in this unforgettable caricature of two campaigning politicians.

Dwight D. Eisenhower (1952) by Norman Rockwell (1894-); collection of Kenneth Stuart, New York.

Dwight D. Eisenhower, a popular wartime leader who became a popular President, was painted for the *Saturday Evening Post* magazine by America's best known illustrator, Norman Rockwell. This painting is one of a series of sketches Rockwell did of Eisenhower just after the general was nominated for President in 1952.

Rockwell's work includes 317 covers for the old *Saturday Evening Post*, illustrations for advertisements of a wide variety of consumer products, and illustrations of the lives of American folk heroes such as Tom Sawyer and Huckleberry Finn.

Rockwell paints cheer and comfort, happiness and humor. An art critic once said that Rockwell's works cannot be described as serious art, but that they have value as an image of what a great people like to imagine themselves to be.

Rockwell's portrait of Dwight D. Eisenhower gives us a stronger impression of the man than a photograph would. The artist has paid careful attention only to the details that show us Eisenhower's warm and friendly personality.

Eisenhower as a personality appealed to the average American. He was a great wartime leader who commanded the largest invasion force in history in Europe during World War II. After the war he was president of Columbia University in New York. President Truman named him commander of the NATO (North Atlantic Treaty Organization) forces in Europe. He ran for President in 1952 and as President guided the country through the difficult cold war period of the 1950s.

In his portrait of the late President, Rockwell seems to be agreeing with the winning 1952 campaign slogan: "I like Ike."

Eisenhower himself enjoyed painting; it gave him relaxation from the many pressures of his public duties. Of his own works, the one Eisenhower liked best was his portrait of Abraham Lincoln. This portrait shows Ike's artistic skill as well as his great insight into human character. And *Portrait of Lincoln* is the only portrait of a President painted by another President.

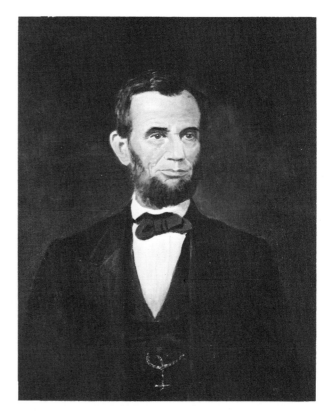

Portrait of Lincoln (1953) by Dwight D. Eisenhower (1890-1969); Brown & Bigelow, St. Paul, Minnesota; permission for reproduction granted by Eisenhower College.

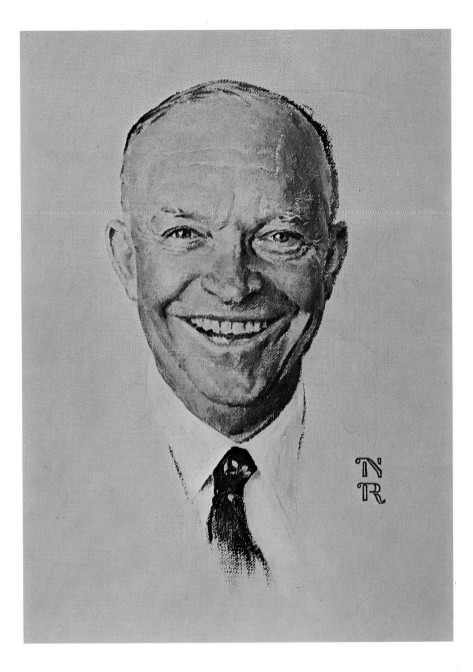

The 1960s were years of great upheaval for the United States. They were marred by a divisive war in Southeast Asia, by disenchantment among the young, by the assassination of great men. But they also were marked by hope and love, by an intense desire for peace, and by America's historic moon landing.

If one work of art can sum up that decade, it is Robert Rauschenberg's *Signs*, a silkscreen *montage* of the men, the women, and the events of those troubled years. Rauschen-berg has arranged the photographs in his montage in a symbolic way. Senator Robert Kennedy's hand appears in the middle of a group of soldiers in Vietnam, expressing his determination to end the war. The wounded black man reaches out for help over the body of Dr. Martin Luther King, slain like Robert Kennedy by an assassin's bullet.

The jeep filled with soldiers has "convoy following" stenciled on its bumper. No convoy follows, but instead peace marchers

expressing opposition to the war. We see Neil A. Armstrong, the first man on the moon, reflected in the visor of fellow astronaut Edwin E. Aldrin. And singer Janis Joplin, the "hard rock" heroine who died of an overdose of drugs, expresses the intensity of her generation in wild and exuberant singing.

Amid all this, there is President John F. Kennedy, the man who ushered in the decade on a note of high hope but who was slain before he could try to fulfill his plans. The President seems to be in deep thought but looking calmly toward the future, as if to remind us— as would the artist—that our real danger lies in forgetting what we must remember.

Signs (1970) by Robert Rauschenberg (1925-); collection of Richard Volk, Akron, Ohio.

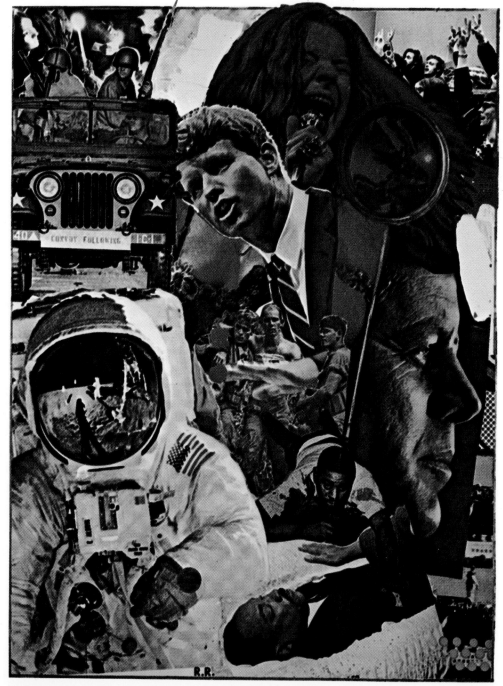

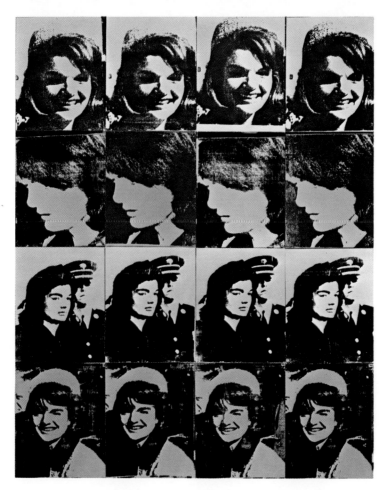

16 Jackies (1965) by Andy Warhol (1930-); Walker Art Center, Minneapolis.

Pop artist Andy Warhol works with images which people know well because they have seen them repeated constantly in advertisements, in newspapers, on television, and even on their own kitchen shelves. He rarely expresses personal feelings about the subjects and events he portrays, but rather repeats the symbols over and over again, leaving the viewer to supply the meaning for himself.

So it is with *16 Jackies*, a silk-screen painting in which Warhol has taken four instantly recognizable photographs of Jacqueline Kennedy Onassis and repeated each of them four times on his canvas. It tells a story the world knows well—the story of John F. Kennedy's tragic death—and we relive it through Jackie Kennedy's face. There is the arrival in Dallas that fateful day, the swearing in of the new President, Lyndon B. Johnson, the funeral procession, and then another smiling Dallas arrival before the tragedy.

Warhol, who is perhaps the most famous of the pop artists, used the commercial *silk-screen* technique in making this print. Through a chemical process the photographs were transferred to a fine silk screen to produce a stencil. The artist then placed the screen over a canvas. Taking the color he had selected, he used a special tool to press the color through the screen and onto the canvas. Warhol printed this screen in a deliberately careless way, as he often does in his works. He does this to vary the images and thus suggest the somewhat distorted ways we often see things today—as in the flickering of a television set or in a quickly glimpsed newspaper photograph.

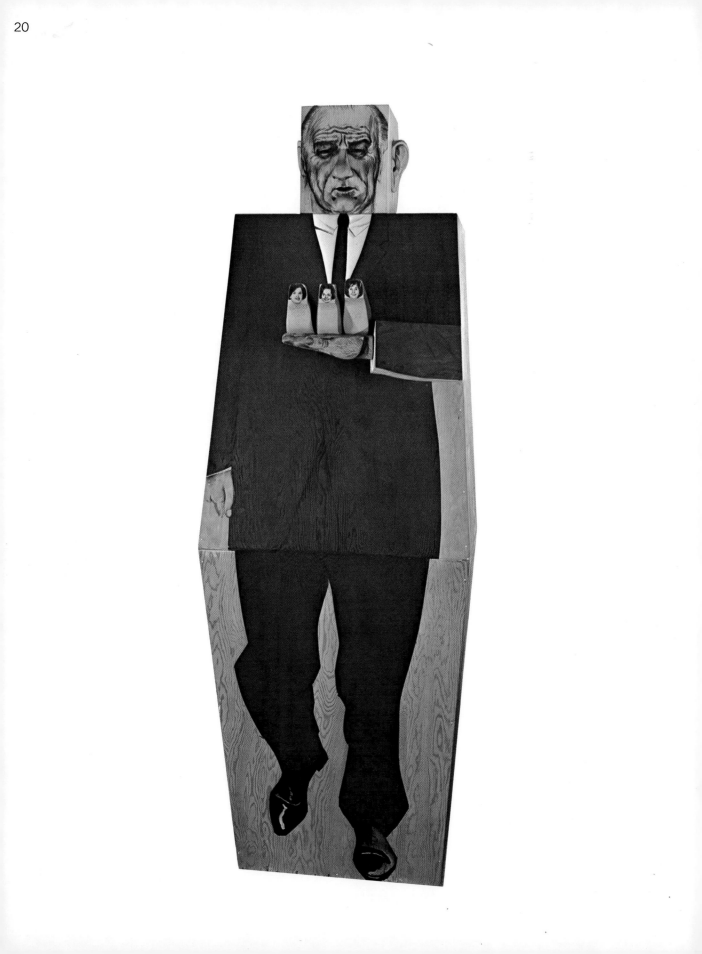

LBJ (1967) by Marisol (1930-); The Museum of Modern Art, New York; fractional gift and extended loan from Mr. and Mrs. Lester Avnet.

Lyndon B. Johnson was a larger-than-life President. His big frame and Texas manner made an impression on all Americans, whether they agreed with his policies or not.

He was a hard-working young man who came to Washington in the early 1930s, before Franklin D. Roosevelt became President. His experience in government—as a Representative, a Senator, and a Vice President—was greater than that of any previous 20th century President. As President, Johnson tried to get opposing groups to agree with one another instead of fighting each other.

Marisol, whose name in Spanish means sea and sun (*mar y sol*), was born in Paris of Venezuelan parents, but she is now an American citizen living in New York City. She combined wood carving, carpentry, and painting to make this sculpture, *LBJ*. She painted the former President on three hollow pine boxes. Because she likes the look of natural wood, she left the rest of the wood plain. Marisol shows LBJ as many of the people he worked with knew him—in motion. We feel LBJ's energy bursting out of the wooden boxes that make up his body.

Marisol always includes in her works something that is amusing or that does not seem to belong there. In this sculpture she has put three little birds on Johnson's carved wooden hand: Lucy Baines, Lady Bird, and Linda Bird—his younger daughter, his wife, and his older daughter. They are modeled after nature's busiest birds, house wrens.

22

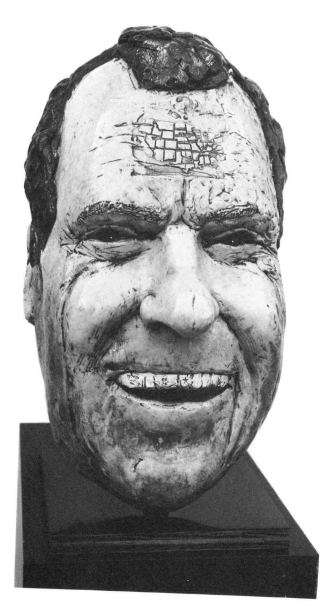

Noxin (1970) by J. Fred Woell (1934-); collection of the artist, Cambridge, Wisconsin.

The job of being President of the United States is bigger than any one man. To show this, the artist made an oversized mask, like those which actors used in a Greek drama. It is open in the back and has tiny peep holes for the eyes.

Woell modeled this sculpture in clay first, and then he made a plaster mold of the clay model. He sealed the mold with shellac and poured a liquid plastic called epoxy resin into the mold in many thin layers, or laminations. A fiberglass cloth soaked in epoxy was put in between some of the layers to give the sculpture strength. The plaster mold was then broken away, and the casting was cleaned, polished, and mounted on a base.

The artist has made his own comments about President Nixon in this work. The dark splotches on his face are composed of photographs inlaid under the top layer of plastic. These photographs depict important moments in Nixon's political career. A map of the United States with a big question mark is imprinted on Nixon's forehead, suggesting the problems he faces as President. The artist tries to point out in this portrait that the mask of the politician is not the politician's alone. The demands of his office alter and color his whole being.

"We are all politicians to a degree," says J. Fred Woell, the artist who created this sculpture entitled *Noxin*. "We mask our real self in order not to hurt other people. We have both a public and a private life, and only few of our very close friends and family know who we are and exactly what we think. We smile when we are sad, in order to make others happy. We face danger when we are afraid in order to inspire courage in others. We are, therefore, not always ourselves. When we are at our best, we are trying hard to be something better than ourselves— bigger than ourselves."

Lawmakers

Before the Constitution was adopted, representatives from the 13 Colonies met in what was known as the Continental Congress. They wrote the Declaration of Independence and laid the foundation for our democracy. Today our laws are made by elected representatives in Congress, which consists of the House of Representatives and the Senate. These two bodies, created by the Constitution, make up the legislative branch of the federal government. They share power with the judicial and executive branches. Before any law is made, it must be approved by a majority in both the Senate and the House—and be signed by the President.

John Trumbull's *Declaration of Independence* deliberately changes the actual circumstances of that historic American event. He painted the men who signed the Declaration as if they all had met to sign the document at the same time. Actually, the signing took three whole days in the sweltering summer of 1776. And at no time were the delegates to the Continental Congress all present together in Philadelphia's Independence Hall.

Trumbull, the painter-historian of the American Revolution, changed the facts in order to give the event the special importance he felt it deserved as the first step in the formation of a new nation. In this case, Trumbull's artistic license was, in effect, a political act.

Trumbull undertook the oil painting at the suggestion of Thomas Jefferson. After it was finished he was accused of including some men who were not signers and omitting

others who were. But his work was accurate; he did show the faces of all the men from the 13 Colonies who signed the Declaration of Independence.

Standing in front of the table at which John Hancock sits are the five men who served on the committee to draft the document: John Adams, Roger Sherman, Robert Livingston, Thomas Jefferson, and Benjamin Franklin. Actually, Jefferson wrote the Declaration by himself, since the others agreed he could write far better than they.

Above all else, Trumbull captured in his painting the serious intent of those men who gathered in Philadelphia. They had disagreed, but now they were of one mind and a single purpose. Because their deliberations were considered treason by George III, the English king, they had worked in secrecy—the windows shrouded and the doors shut.

And so in that poorly lit room they signed the Declaration of Independence. The war against England had already begun. Paul Revere's ride had taken place a year before, and George Washington had been named to command the Continental Army.

Trumbull served in that army as a maker of military maps, and, for a few weeks, as an aide to General Washington. Later in his life, he made a larger copy of this painting to hang in the Rotunda under the great dome of the Capitol in Washington.

Declaration of Independence (1786-1794) by John Trumbull (1756-1843); Yale University Art Gallery, New Haven.

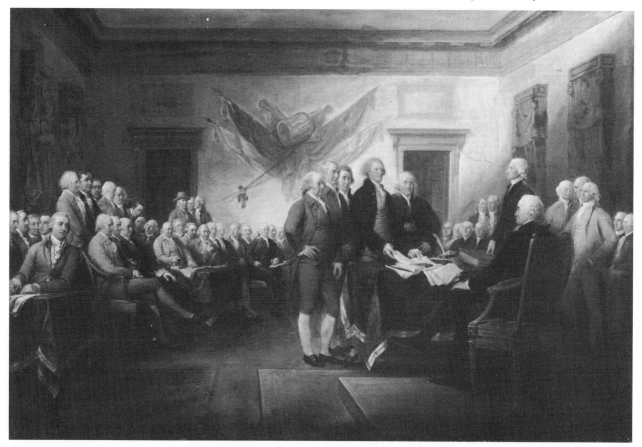

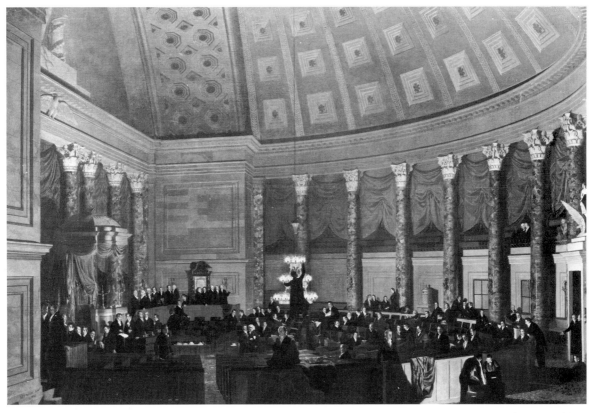

The Old House of Representatives (1822) by Samuel F. B. Morse (1792-1872); The Corcoran Gallery of Art, Washington, D.C.

Most Americans know Samuel F. B. Morse as the man who invented the telegraph. Few realize that he was also an artist. *The Old House of Representatives* is the best of Morse's big canvases. Using a room next to the Old House chamber, he worked on this painting 14 hours a day for almost a year and completed it in 1822. The city of Washington was just 22 years old, James Monroe was President, and 80 members of the House recently had moved into this new chamber.

All but one of the 80 Representatives sat for Morse while he painted their portraits, and he sketched the remaining one from the visitors' gallery. The painting also includes Chief Justice John Marshall and six justices of the Supreme Court. They are standing to the right of the speaker's platform.

Morse had a difficult time with the painting. He had to redraw the complicated perspective of the chamber three times. He con-

stantly studied the lighting of the central chandelier because he had decided to catch the moment when the members were gathering for a night session and the chandelier was being lit. The painting presents a dramatic scene of mellow light, one that seems to say, "History is being made in this hall."

But the public did not recognize Morse's artistic skills. He abandoned painting early in his career and then turned to the experiments in electricity that led to his famous invention.

Twenty years after he painted this work, Morse was sitting in the gallery of the chamber he had committed to canvas. He waited anxiously to see if the House would pass a bill authorizing him to string a telegraph line from Washington to Baltimore. The bill was approved, and two years later, in 1844, Morse tapped the first message over the 41 miles of line: "What hath God wrought!"

William Gropper had no intention of glorifying the United States Senate when he painted *The Senate* in 1935. He was angry and impatient with some Senators for postponing and delaying measures that he and others felt were necessary in those days of the Great Depression. So he put his feelings down on canvas, as he often did in his fight for social justice.

The result was not very flattering. Gropper gave the speaker in his painting an exaggerated potbelly, waving arms, and a very open mouth—which indicates that he has been talking endlessly and may go on forever. The Senator to his right seems to realize this and has propped his feet up on a chair to be comfortable during the long wait. The third Senator has lost interest completely, finding comfort in his newspaper. Several of the Senators' desks are completely empty, which is another sign of inactivity.

Gropper could have been portraying a *filibuster*, a legislative device whereby a Senator or a group of Senators literally try to talk a measure to death. More likely, he was depicting what he thought to be a typical day in the Senate during the Depression years.

The artist's early training as a political cartoonist sharpened his ability to condense what he saw into a few simple shapes. The figures of the Senators are thick solid masses, and only a few lines suggest detail. Gropper uses angles and planes to focus attention where he wants it. In this painting, the tops of the desks are tilted up to draw attention to the speaker.

It has been said that Gropper's propaganda is always art, and that his art is sometimes propaganda. There is no doubt that he used his paintings and drawings in an effort to bring about social change. But that fact does not lessen the value of his work as art.

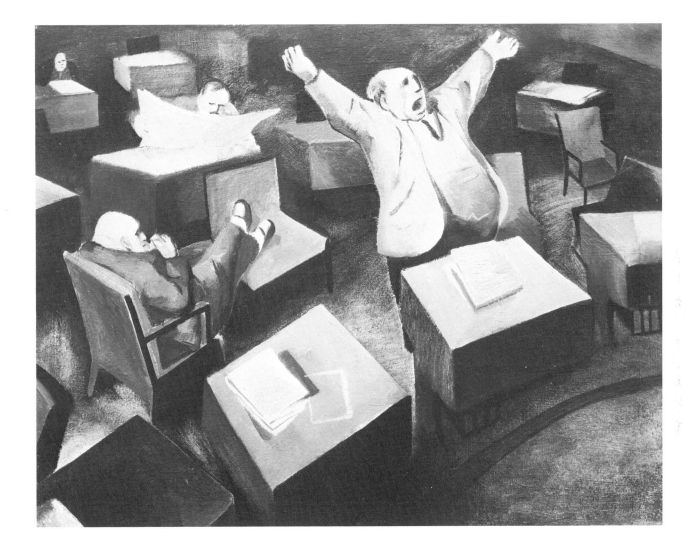

The Senate (1935) by William Gropper (1897-); The Museum of Modern Art, New York; gift of A. Conger Goodyear.

Issues

Artists express their own ideas and feelings in their works, usually interpreting their subjects in a personal way. An individual looking at a work of art tries to understand the ideas the artist is expressing. However, it is natural for any painting to remind the viewer of things in his own life. Everyone, including the politician, looks at art partly from his own special point of view.

When paintings and other works show unhappy aspects of the human condition, a politician may see such works as comments on problems he may be able to help solve. Thus even if an artist did not originally create his work to have a political interpretation, a politically minded viewer may find that the art points out a relevant political issue. Several such paintings are included in the following section.

Human Needs

American artists have often used their art to comment on the conditions of human life. The problems of unemployment, poverty, emotional deprivation, and loneliness are of concern to artists, just as they are of concern to politicians. Some of the most eloquent and enduring protests to America's social problems have come from artists, and their works have helped dramatize the need for change and improvement.

Unemployment was widespread during the Great Depression in the 1930s. Millions were out of work, from the bank president to the janitor. And to stay alive, men stood in lines waiting for handouts of bread and other food.

In *The Bread Line*, which he drew for a magazine, artist Reginald Marsh shows the sadness of these men who have lost their pride and dignity because they cannot find jobs. He captured for all time the great cost, in human terms, of widespread unemployment.

Marsh, who painted as well as sketched, believed that artists should show all sides of life. He created art that showed misery and despair, in the hope that it would result in action to improve people's lives.

Many artists were among the unemployed during the Depression, but some of them made a living working on the Federal Art Project. The government gave these artists their materials, a place to work, and a paycheck every week.

Ben Shahn, Philip Evergood, and some of the other artists represented in this book thus were able to paint full time and develop their talent during the Depression. They did not have to give up their art to work at something else in order to eat. Like Marsh, these artists boldly pointed out the wrongs in our society. Today many of their paintings hang in government buildings in Washington, D.C., and other cities.

The Bread Line (1929) by Reginald Marsh (1898-1954); Library of Congress, Washington, D.C.

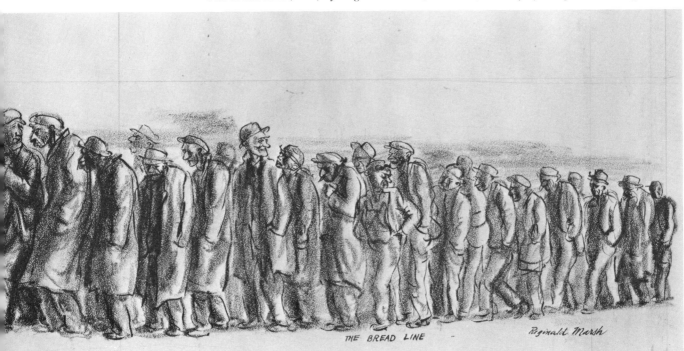

THE BREAD LINE — Reginald Marsh

The Library (1961) by Jacob Lawrence (1917-); National Collection of Fine Arts, Smithsonian Institution, Washington, D.C.

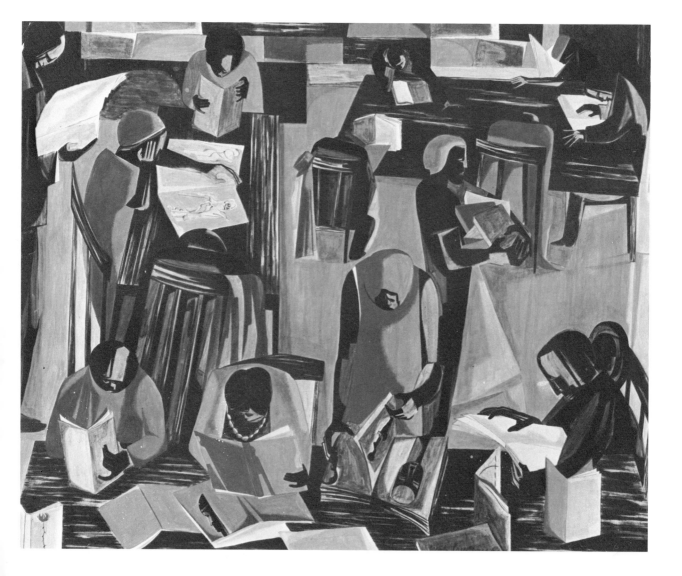

Jacob Lawrence is a black artist who in this picture has chosen a subject that he believes is important to the future of his race—education.

In *The Library*, an oil painting, we see a room full of people reading and studying. Lawrence may be saying that these black people are the object of discrimination, that they are in a segregated library. Or he may be reporting the strong movement among black Americans to learn about their history and culture.

Jacob Lawrence has rearranged what he saw in the library into flat patterns of shapes and colors. He has simplified the people into oval shapes. He has flattened them out so they look more like two-dimensional decorations than three-dimensional people. These rounded shapes contrast with the rectangles of the library tables, books, and magazines. He tipped the table tops up to see them better, as though he had stood on a ladder to get a bird's-eye view. He tried not to give the feeling of depth, for even though the figures in the background are smaller than those in the foreground, they don't seem to be any farther away. Everyone seems to be close together. His colors are raw and sharp: red, blue, yellow, and green. He has used black and brown to delineate the shapes, with white to accent them.

A native of Harlem in New York, Jacob Lawrence worked for the Federal Art Project during the Depression. In this period he became interested in showing the history of the American Negro, and now he is famous for his paintings of the struggle of blacks for freedom and equality.

Andrew Wyeth is a well-known American artist who works in almost complete isolation from other artists and from the busy, urban world in which most Americans live.

Wyeth had no formal art training. Yet his simple, often sad paintings of the rural landscapes around his homes in Cushing, Maine, and Chadds Ford, Pennsylvania, convey a human message that is understood by almost all who view his works.

Andrew Wyeth completes only two or three paintings a year. He chooses unassuming people and simple things for his subjects, investing them with a sense of timelessness and a mysterious melancholy. He says that before he considers his paintings finished, they must give him goose pimples.

This painting, *Christina's World*, hangs in the Museum of Modern Art in New York, where it is one of the most popular paintings. It was inspired by Wyeth's friend Christina Olson. Although crippled, she refused to use a wheelchair. One afternoon in 1948 Wyeth discovered that she had dragged herself out into an empty field and was looking questioningly at the group of unpainted farm buildings in which she lived. The painting conveys a sense of her remoteness and isolation. It seems that Christina's world is narrow and lacks opportunity.

Christina can be seen as a representative of one of the many poor people in this country who live in rural areas, hidden away from the view of those of us who fly overhead or drive past on the highways.

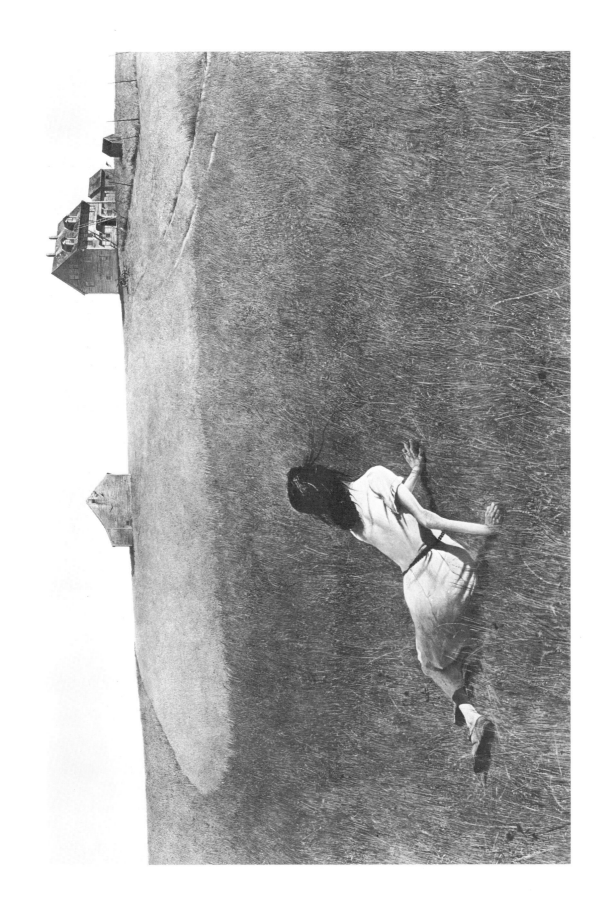

Christina's World (1948) by Andrew Wyeth (1917-): The Museum of Modern Art, New York.

Love to Grandmother (1965) by Eleanor Jane Mondale.

Contrast the feelings of isolation and loneliness in Andrew Wyeth's *Christina's World* with the emotions of love and affection in this drawing by a five-year-old girl, Eleanor Jane Mondale. She drew the picture for her grandmother with a felt pen. She has shown herself on the left with a big smile and her grandmother on the right. Grandmother's arms go all the way around Eleanor Jane. Even a child's simple drawing can express feelings of love and devotion in the family.

These emotions are also expressed in *Maternal Caress*, the work of a mature artist, Mary Cassatt. The daughter of a wealthy family in 19th-century Philadelphia, Mary Cassatt pleaded with her father to let her go to Paris to study art. He reluctantly agreed, but his parting words to her were "I wish you were dead." But Mary Cassatt studied with Edgar Degas and became the most important 19th-century woman artist, accepted by the *French Impressionists* as a member of that school of painting.

Maternal Caress shows the influence of Japanese woodcuts. Everything is flat. There is no air or atmosphere, no volume or depth. Our brain must fill in what our eyes do not see. We know that the baby is soft, round, and cuddly, but Mary Cassatt used no shading to define the baby's shape. Similarly, the folds of the mother's dress are just dark lines; there are no shadows to describe them.

We know that love, affection, and emotional support are as essential to a human being as food, clothing, and shelter. Such support is particularly important during the early years of infancy and childhood. Tragically, thousands of children do not benefit from the emotional love and stimulation needed for a healthy and hopeful life. We should be reminded of the injustice of this deprivation. Perhaps these needs were best expressed by psychologist Erik Ericson when he said: "The most deadly of all possible sins is the mutilation of a child's spirit."

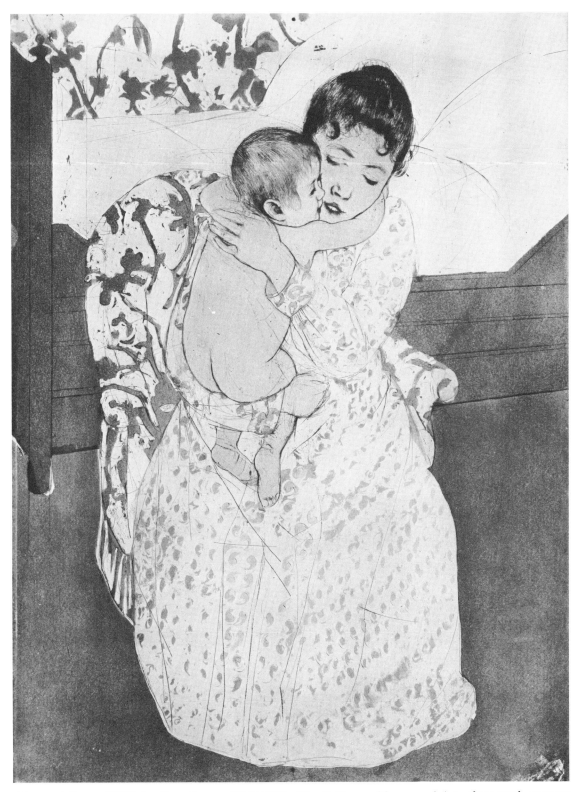

Maternal Caress (1891) by Mary Cassatt (1845-1926); The Baltimore Museum of Art; photograph courtesy Library of Congress.

A look at *Sunday*, a painting by Edward Hopper, reveals immediately how lonely, dreary, and boring life can be for those who are old and poor in a large city. In his paintings of ordinary Americans in settings that are familiar to all of us, Edward Hopper often shows us the loneliness of people all around us.

Here is an old man on a Sunday morning with nothing to do. He is all alone. His head is bowed. His eyes are lowered. His arms are folded; they form a barrier between the observer and the man in the painting, increasing the feeling of loneliness. There is nothing in this painting except the man sitting in front of the empty store.

Edward Hopper sets up two artistic contrasts to heighten the mood of isolation. He contrasts the white light of the sun with the dark shadows formed by the buildings. The sunlight is too bright, overlighted like lights on a stage, and the shadows are too dark; they hide the form of the building. Hopper also contrasts the vertical lines of the store fronts with the horizontal and diagonal lines of the board sidewalk and the bottom and top of the store's windows. These diagonal lines seem to continue beyond the picture frame, suggesting blocks and blocks of empty stores, which there are in many blighted areas of our cities.

The painting suggests these words of President Kennedy, who expressed concern about what happens to old people in our country: "It is not enough for a great nation merely to have added new years to life . . . our objective must also be to add new life to those years."

Sunday (1926) by Edward Hopper (1882-1967); The Phillips Collection, Washington, D.C.

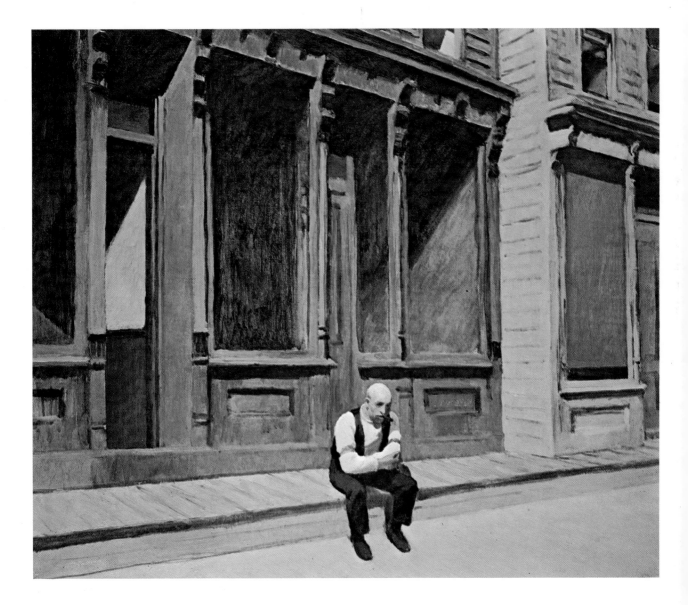

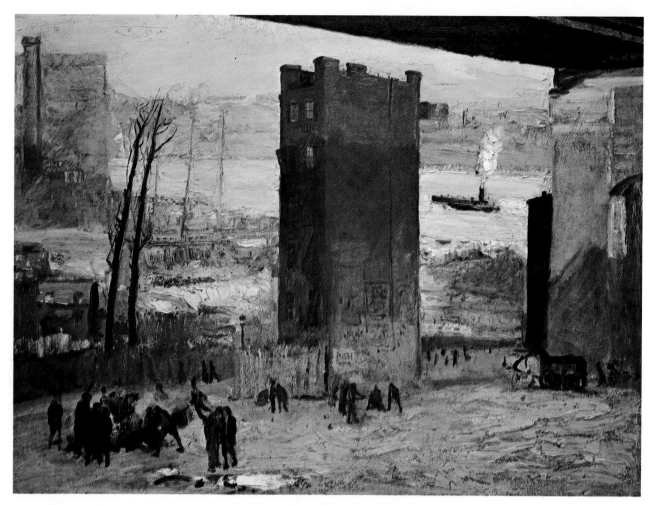

The Lone Tenement (1909) by George Wesley Bellows (1882-1925); National Gallery of Art, Washington, D.C.

George Bellows was an artist who painted everyday life in New York City. He showed the energy and excitement of the bustling, growing city in his paintings of ordinary working people—dock workers, prize fighters, young boys, and other people who made up the street life of the city.

A star athlete in college, Bellows chose to become an artist rather than a major league baseball player. He studied art with Robert Henri, the leader of the *Ash Can School*—a group of eight newspaper illustrators who chose to break with artistic tradition by painting "unimportant" city subjects.

In 1909 Bellows painted *The Lone Tenement*, a picture of a lonely apartment building overshadowed by a huge bridge, a symbol of progress. He painted the scene with romantic hues. Instead of using grimy, drab colors, he used gold, blue, and lavender, which are softened by the late autumn sunlight. He placed the tenement in the center of the painting and balanced it on either side with similar vertical shapes. Two black trees and three masts of a sailing ship in the background lean slightly toward the tenement, making it the center of attention.

This painting, which hangs in the National Gallery in Washington, D.C., asks a question of political and social significance: what happens to the lives of people in the city when "progress" intrudes on their homes?

Issues: War

Whenever America has gone to war, artists have had something to say about it. They may express patriotic support, or simply honor the American soldier. Often they merely comment on the sadness, the death, and the destruction of war. And sometimes they dissent from one war—or all wars.

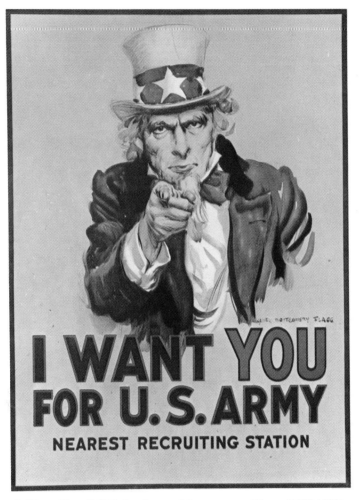

I Want You (1917) by James Montgomery Flagg (1877-1960); Library of Congress, Washington, D.C.

James Montgomery Flagg drew his own face on a poster that was reproduced 4 million times and pasted on walls all over the United States.

Flagg, a magazine illustrator and portrait painter, drew the famous *I Want You* poster to encourage men to sign up for the army and fight in World War I. The United States entered the war in 1917, three years after it began. But not all Americans wanted to join the war. Some wanted the United States to remain neutral, not to commit itself to either side. President Woodrow Wilson decided to try to convince the country that we had to fight the war in order to make the world safe for democracy. Artists, illustrators, singers,

actors, writers, educators, poets, historians, and photographers were asked to contribute their support to the war.

Because there were few radios and no television sets at the time, posters were often used to get the message of patriotism across to the public. The country was flooded with posters: they were in street cars, on billboards, on barn walls, along highways, and in public buildings. The posters called on the public to be patriotic, to buy Liberty Bonds to help pay for the war, and to join the army. *I Want You* was one of the most famous and widely distributed of these posters.

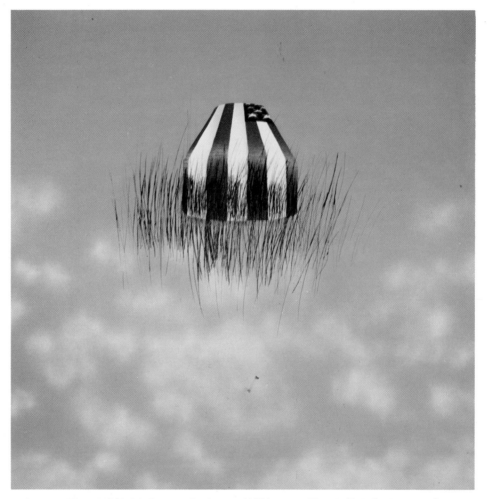

American Hero (1968) by Clayton Pinkerton (1931-); Illinois Bell Collection, Chicago.

Many artists have used their talents in support of the policies of government. Flagg's *I Want You* poster, for example, greatly helped to unite the country during World War I. Other artists, especially contemporary ones, have tried to show people what they believe is wrong with government policy. In *American Hero*, Clayton Pinkerton is protesting against the Vietnam war.

American Hero is a sad and quiet painting. A flag-draped coffin floats somewhere between earth and heaven, cushioned by green rushes so familiar to fighters in Southeast Asia. Except for a few puffy clouds, there is nothing else to distract us from the painting's message. The artist has stated the message in these words: "In this war our soldiers have to be dead before they become heroes."

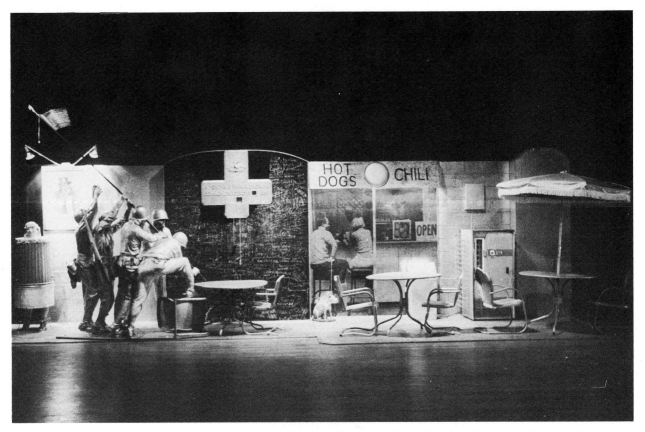

The Portable War Memorial (1968) by Edward Kienholz (1927-); Wallraf-Richartz Museum, Cologne, Germany.

Artists use many different materials to create works that express their feelings. Some use paint, some use metal or wood or plastic. Others, like Edward Kienholz, put together a collection of real, life-sized objects to create a scene that will remind us of our own lives.

Kienholz titled his work *The Portable War Memorial*, and he calls it a *tableau*. He created it to show his opposition to war. The tableau presents its message to the viewer from left to right, like a book. On the left Kienholz has placed symbols of war—a poster of Uncle Sam used to recruit soldiers in World War I; Kate Smith, a popular vocalist, singing the patriotic song "God Bless America"; and American marines on Iwo Jima Island during World War II.

The Marines are standing near a large tombstone on which are the names of many countries that no longer exist. Kienholz may be saying that the size of the earth does not change, but that men suffer greatly in fights to change boundaries that represent countries.

Kienholz calls the next section of the tableau "Business As Usual." The two people sitting at a hot dog stand, a soft drink machine, a small dog, all remind us of our own lives—now.

By placing symbols of war next to objects from our everyday lives, Kienholz is telling us that we have come to accept the violence of war as a natural part of our lives. He thinks that it is natural for people to fight. But he also regrets the deaths of men in war and believes that good leaders could help men to avoid wars.

F-111 (1965) by James Rosenquist (1933-); collection of Mr. and Mrs. Robert C. Scull, New York.

James Rosenquist began his career as an artist by painting billboards. His painting entitled *F-111* consists of four large sections the size of billboards. These sections cover the walls of an entire room.

F-111 is the name of a military plane. The artist used it in his painting as a comment on our country's war economy. At the time he painted *F-111*, in 1965, the F-111 was the nation's newest fighter-bomber. The cost of

developing the plane was many millions of dollars. As long as the plane was being designed and built, many people could count on having jobs and money to support their families.

But the artist objects to the manufacturers of war materials who say we must make guns and bombs and war planes because people must have jobs. He thinks that the millions of dollars spent for war could be spent instead

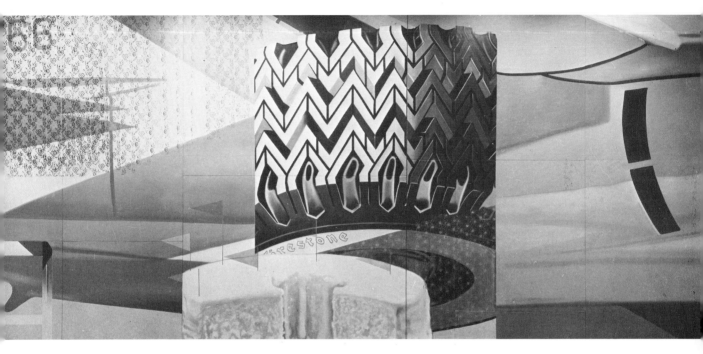

on other problems, like education, housing, and protection of the environment.

Like Andy Warhol, Rosenquist is a pop artist; in his work he uses images from the mass media—from advertising, radio and television, comic strips, and billboards. Sometimes pop artists just paint pictures of soup can labels or light switches or coca-cola bottles.

When he was painting billboards in New

York, Rosenquist got used to seeing huge figures, objects, and patches of color right up next to his face. He could only see a part of the billboard at one time. He still likes working with paintings of huge size.

F-111 is 10 feet high and 86 feet long. The plane stretches from one end of the painting to the other. But the length of the plane is broken up by other pictures. The end of the plane has a pattern printed on it. This pat-

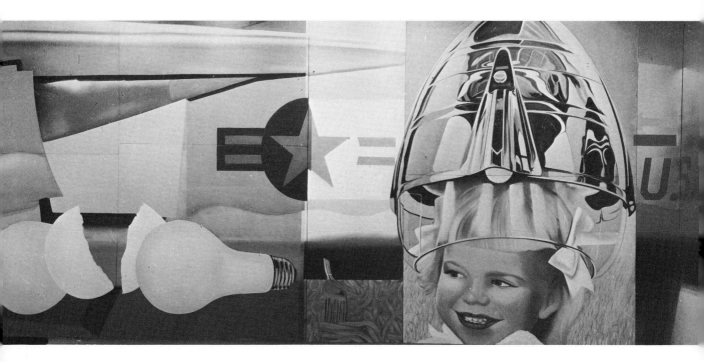

tern was made with a wallpaper roller and a stencil of hard, artificial flowers. It reminds the artist of the pollution which comes from the huge plane.

In the next panel are pictures of an angel-food cake and a tire. The flags stuck into the cake represent birthday candles, and the cake represents food and the energy we get from food. The tire reminds the artist of a truck. Rosenquist says that the F-111 could have been "a giant birthday cake lying on a truck for a parade" but that instead it was created to be "a horrible killer" for war.

Next we see three light bulbs, one of which has been broken in two. The artist has painted it that way to remind us of the blinding light that occurs in a bombing. Rosenquist painted a little girl under the hair dryer to make the picture look real to us. She is a human being, and the artist wants ordinary

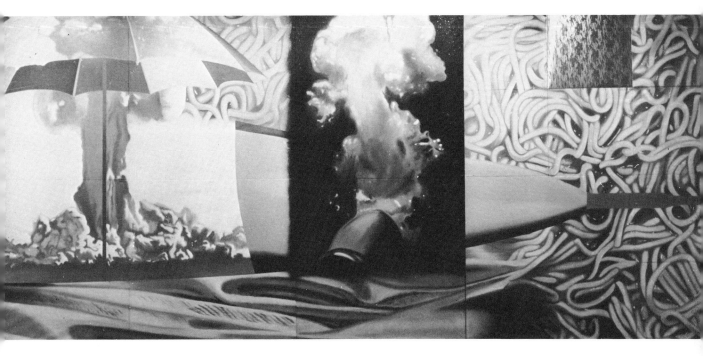

people to understand what it means when we build huge bomber planes.

The next panel shows a blue umbrella shielding an atomic bomb explosion. A generation ago, everyone was shocked and threatened by atomic weapons. The artist says that "now the young people are not afraid of an atomic war . . . and think that it won't occur." Next Rosenquist has painted a man swimming under water. The huge bubble over his head also reminds us of the atomic bomb. In order to make the air bubble, the man had to take a huge "gulp," like an explosion, Rosenquist says.

A huge fold that looks like a gray cloth is spread on the bottom of the picture. It gradually changes into food—into orange spaghetti. Again the artist seems to be objecting to the argument that the production of war materials is necessary to create jobs.

Issues: Freedom

The United States Constitution guarantees a vast range of freedoms, among them freedom of speech, religion, and the press, the right to a fair trial, and the right to petition the government. These and many other liberties have been challenged many times in American history, and just as often artists have expressed their support for the basic human rights embodied in the Constitution.

This painting, *The Passion of Sacco and Vanzetti*, presents the artist's opinion about one of the most controversial and famous trials ever held in the courtrooms of this country. The painting serves as a reminder that America's freedoms must be carefully protected from abuse.

Ben Shahn has painted Nicola Sacco, a shoemaker, and Bartolomeo Vanzetti, an itinerant fishpeddler, in their coffins. Both men were executed after a jury found them guilty of killing a paymaster and his guard and stealing $16,000 in South Braintree, Massachusetts.

The story of their trial became famous because many people believed that the men were being denied their basic freedoms and being tried for their background and their political beliefs, not for the murders. Sacco and Vanzetti were Italian immigrants who were not United States citizens. Outside of the courtroom, the judge in the trial admitted that he hated Italians. Sacco and Vanzetti also believed in *anarchism*, a theory that people should be able to run their own lives free from the control of organized government. This theory was unacceptable to many people in the country.

In spite of protests by people who believed that Sacco and Vanzetti were being tried for their political beliefs, the two men were found guilty. The governor of Massachusetts then appointed a committee of three men to look into whether the decision in the case should be changed. The committee decided to let the verdict stand, and so Sacco and Vanzetti were executed. However, their guilt still remains in doubt today.

One hundred and forty-four poems, five plays, and seven novels were written to protest the deaths of Sacco and Vanzetti. Ben Shahn created a series of paintings on the subject, including this one.

The portrait in the background is of the judge who condemned Sacco and Vanzetti to death. The "mourners" at the side of the coffins are members of the committee that upheld the judge's decision.

The Passion of Sacco and Vanzetti (1931-1932) by Ben Shahn (1898-1969); Whitney Museum of Modern American Art, New York; gift of Edith and Milton Lowenthal in memory of Julian Force.

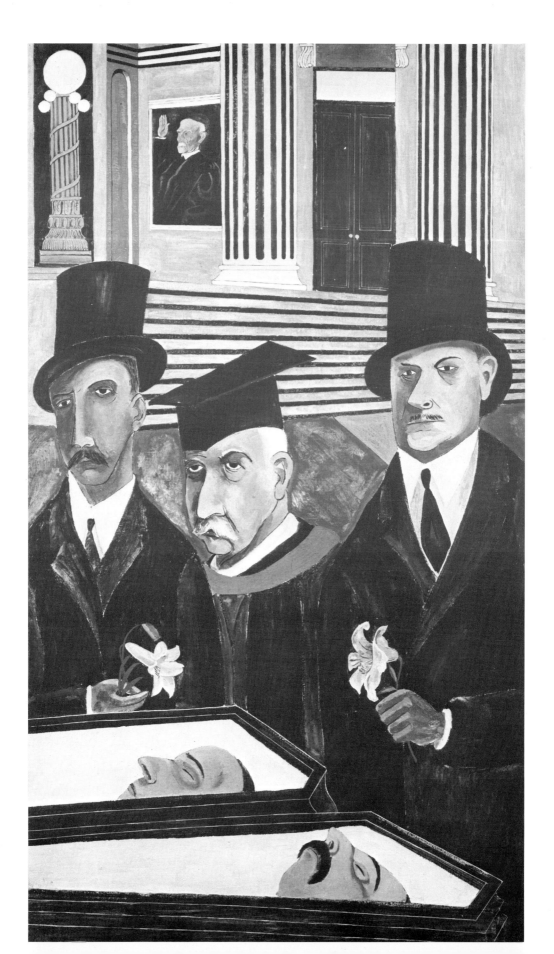

48

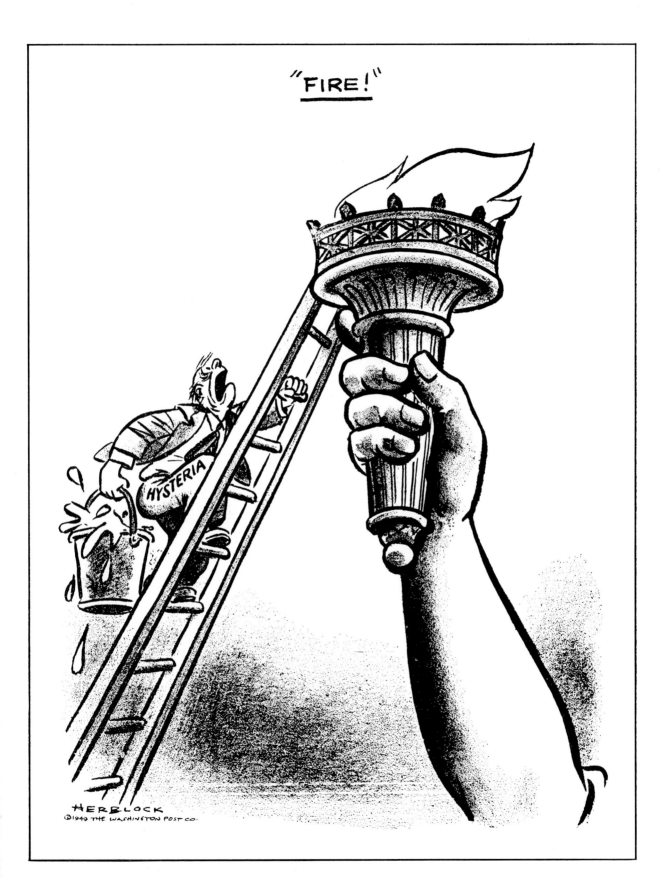

Freedom of the press comes to life in the drawings of Herblock. His stinging political cartoons on the editorial page of the *Washington Post* please or anger readers, depending on their point of view.

In 1949, when Herblock drew *Fire!*, many Americans were confused and afraid about what was happening in their country. A committee of Congress, the House Un-American Activities Committee, was investigating people it believed were not loyal to the American government.

The committee tried to say that any American who would not publicly swear his loyalty to his country was a traitor. It frightened many people who believed that the committee members were calling anyone who disagreed with them "un-American" or a traitor. As a result many people were afraid to criticize the government at all, even though this is a right that the Constitution guarantees to all Americans.

Herblock was not scared by the committee. He used his cartoons to state his opposition to the investigators loudly and often. In this cartoon, a panicked man with a bucket of water climbs a ladder to put out the fire on the torch of the Statue of Liberty. That fire represents freedom of speech and the other important freedoms in the Bill of Rights. Herblock is saying that the country's fear about un-American activities may lead to the destruction of the basic freedoms of our democracy.

Eventually, with the aid of the press the leaders of the movement were proved wrong, and the excitement died down. Thomas Jefferson once said: "The only security of all is in a free press."

Fire! (1949) by Herblock (1909-); from The Herblock Book *(Beacon Press, 1952).*

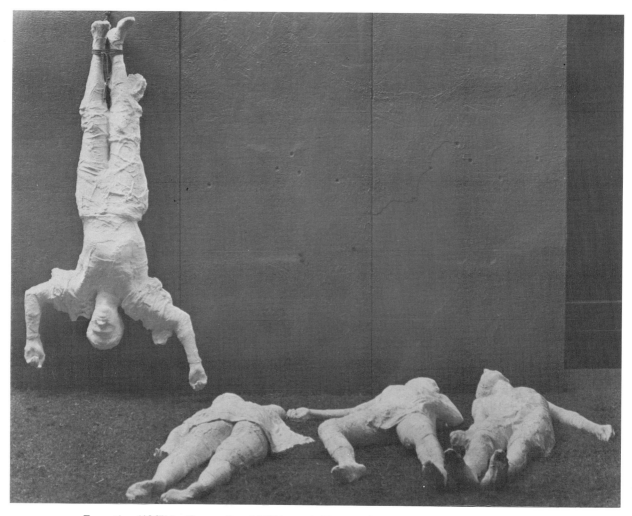

Execution (1967) by George Segal (1924-); Vancouver Art Gallery, Vancouver, Canada.

The mute and frozen white plaster figures in George Segal's *Execution* testify to the extreme measures which are used in some countries to wipe out political opposition in times of war or revolution. Newspapers are censored, people are jailed without trials, and freedom of speech is abolished.

George Segal casts his figures by soaking strips of cheesecloth in plaster and covering up part of a living subject with layers of the wet strips. When the plaster hardens, it is cut away and Segal covers another section of the subject's body. The pieces are later reformed into whole figures and placed in a real setting. The surfaces of the figures are not finished to look real. They are so rough that facial expressions don't show; thus the entire body expresses the mood. Segal has said, "My biggest job is to select and freeze the gestures that are the most telling. I try to capture a subject's gravity and dignity. I'm dependent on the sitter's human spirit to achieve total effectiveness."

George Segal's figures are lonely and forlorn like those in Edward Hopper's paintings. His subjects are working men and women—truck drivers, gas station attendants, store clerks—caught in their everyday activities.

Spirit of '76 (1970) by Leland Fletcher (1946-); collection of the artist.

The objects in this work of art have been used by protestors to show that they are dissatisfied with life in the United States. Fletcher put these objects together to make people think about the violence that has occurred and about the conditions that are being protested.

The name, *Spirit of '76*, refers to the spirit of the colonists who fought against England in order to make the United States a separate, free country. In this work Fletcher suggests that Americans often disagree strongly about important issues. He seems to be pleading with us to deal effectively with our problems and maintain our basic freedoms.

Leland Fletcher, a young Minnesota artist, created *Spirit of '76* to show how strongly some people feel about what is wrong with America. This work of art is made of a box that formerly contained dynamite, a red flag used by student strikers, an American flag, and a green bottle. The piece of cloth sticking out of the bottle can be set afire and the bottle becomes a bomb.

Issues: Quality of Life

Like many other Americans, artists have been focusing their attention on the problems that seem to be an inevitable part of life in an industrial society—pollution of the water, air, and land, competition between technology and humanity, explosive divisions within society, and crowded, hurried life styles. They too are alarmed, and they are using their art to encourage us to act.

Americans are becoming concerned about the careless way we have treated our natural resources. We have polluted our rivers, lakes, and oceans. We have dirtied the air with fumes from cars and factories, and we have piled mountains of ugly trash and garbage around our countryside. We have created noises which are painful to our ears, smells which irritate our noses, and sights which are offensive to our eyes.

Robert Rauschenberg made this poster for the first Earth Day, which was observed on April 22, 1970, with teach-ins, clean-up campaigns, and parades. The poster focuses on problems that have been caused by our growing population and by the leftovers from our manufacturing industries. The poster shows that we have damaged the earth's delicate balance among plants and animals and man.

In this poster Rauschenberg has used photographs of the polluted world and of the animals, such as the gorilla, which may not be able to survive this pollution. In the center of the poster is the American bald eagle, the national bird, which is becoming very rare. The message of *Earth Day* is clear: Our survival will depend upon how wisely we use our resources.

Earth Day (1970) by Robert Rauschenberg (1925-); Leo Castelli Gallery, New York.

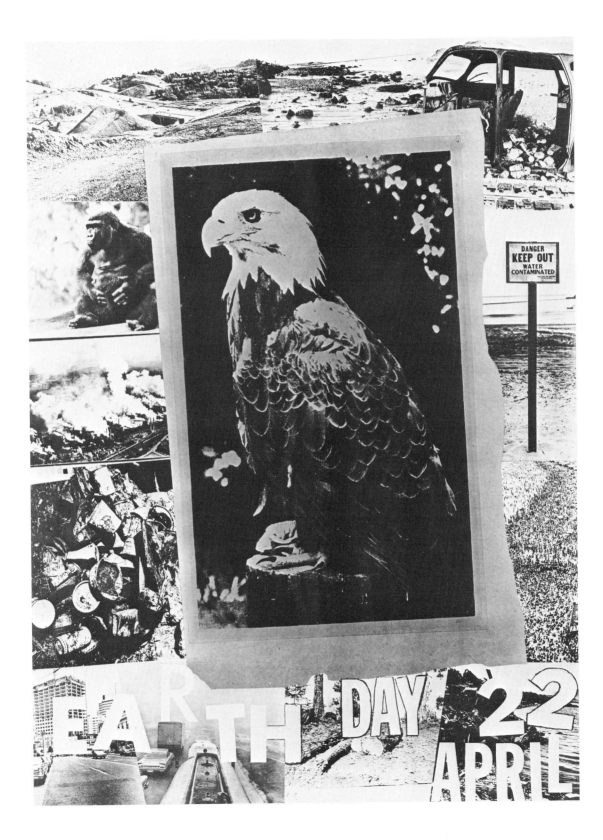

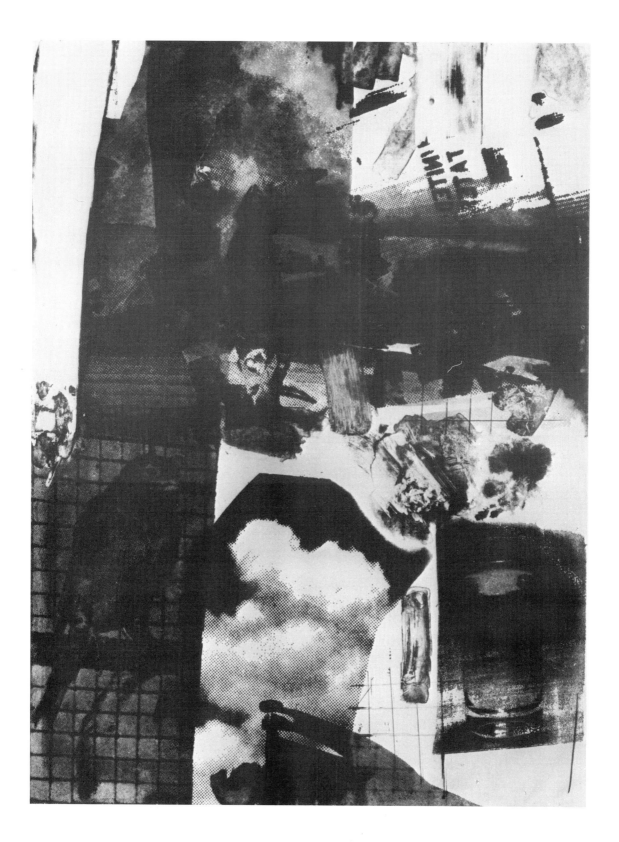

*The Rivals (1963) by Robert Rauschenberg (1925-):
Leo Castelli Gallery, New York.*

In *The Rivals*, Robert Rauschenberg has put together objects we usually do not see together, combining them in order to raise questions about what our country is doing with regard to physical science, space exploration, and biology.

This print should be read like a book, starting on the left-hand side. First, there are two little space monkeys, Able and Baker. Next is a canary bird in a cage, then a cloud, a glass of polluted water, shapes of leaves, and finally, in the upper right-hand corner, a United States space capsule.

What does this picture mean? From the title, *The Rivals*, we may guess that physical science is competing against biology (which represents living people and animals and plants). Are they competing for control of the earth? of nature? of outer space? In any case, Rauschenberg seems to be suggesting that science should contribute to life, not destroy it or compete with it.

The artist does not want to state his message so clearly that everyone will understand it all at once. He wants us to think about it carefully. It is as though he were asking a riddle, one that has no easy answer, like the riddle the Mad Hatter asked Alice in *Alice in Wonderland*: "Why is a raven like a writing desk?"

Billboard (1957) by Grace Hartigan (1922-); The Minneapolis Institute of Arts.

This painting, called *Billboard*, is by Grace Hartigan, an artist who signed her first canvases "George" because she was afraid that she would be discriminated against as a woman. This painting is about the hustle and bustle of the fast-moving lives we lead today. We need the title of this painting in order to understand its content: the artist has taken images of advertisements she has seen on billboards while driving quickly by.

Grace Hartigan's painting is unusual because it uses several different artistic styles. Most of the paintings we have seen in this book are realistic art; they show us things we can recognize right away. But many modern artists create abstract art; they just use colors, shapes, and textures on their canvases. *Billboard* is unusual because it is realistic and abstract at the same time. This makes the painting a little confusing to us. It might have been easier for us if Grace Hartigan had made *Billboard* all abstract, only painting colors and shapes from billboard advertisements. But she has included some things which we can recognize—a child's face, a carton of oranges, and a bottle of root beer.

Billboard is a little like a pop art painting, because it includes familiar objects from advertisements. But if Grace Hartigan were a true pop artist, she would have recreated a billboard ad in her painting, perhaps enlarging the root beer bottle, or repeating it many times over.

Billboard is also a little like an *op art* painting. The artist makes our eyes dance across the picture surface. She has placed warm colors (yellows, reds, and oranges) next to cool colors (blues, greens, and purples). Warm colors come forward and cool colors move backward; our eyes jump about, unable to rest. But if Grace Hartigan were really an op artist, she would have done something more simple. She might have taken a huge canvas, painted it all blue, and painted big yellow polka dots the size of tennis balls all over the surface in a geometric arrangement. Our eyes then would be seeing an optical illusion.

This painting is highly organized, happy and optimistic in feeling. Perhaps Grace Hartigan believes that there can be order and happiness within the hectic pace of modern life.

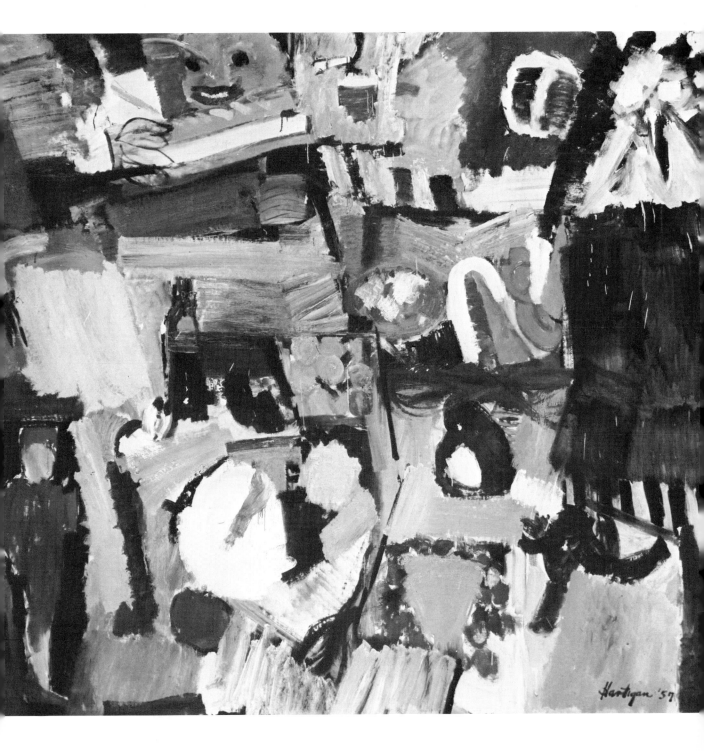

Hartigan '57

Progress and Reform

Great national problems have been accompanied by widespread public efforts to find solutions. Artists have been involved in the events, as interpreters and chroniclers and sometimes even as active participants. Whatever the cause— separation from England, the Civil War, the labor movement, civil rights, the demand for peace—artists have played an important role.

Paul Revere (c. 1765) by John Singleton Copley (1738-1815); Museum of Fine Arts, Boston.

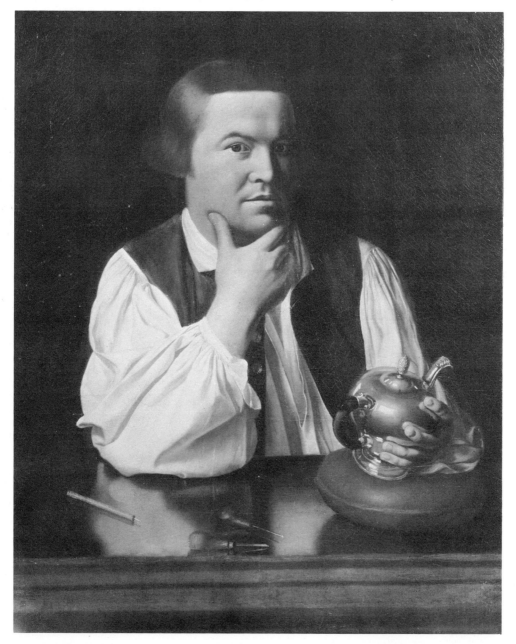

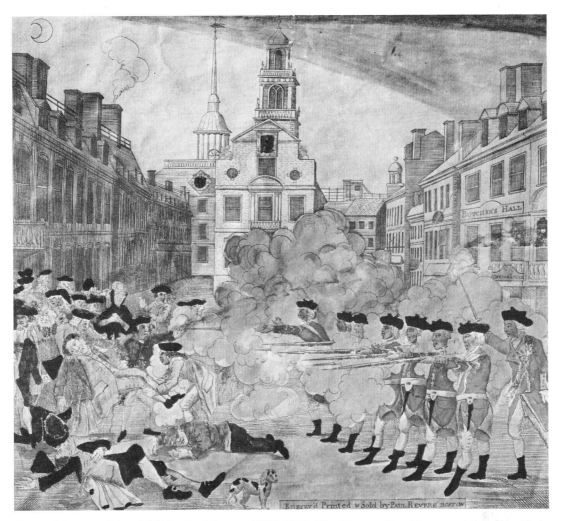

Boston Massacre (after 1770) by Paul Revere (1735-1818); The Metropolitan Museum of Art, New York; gift of Mrs. Russell Sage.

Paul Revere, one of the heroes of America's colonial period, is portrayed as a man of the people in this portrait by John Singleton Copley. Revere wears his work clothes, and at his elbow are the tools of the silversmith trade he practiced. His informal appearance makes this painting fairly unusual; in Revere's day, it was the custom for the subject to dress up in his best clothes and pose formally.

Paul Revere was known throughout the colonies for his honesty. Unlike some silversmiths, Revere always used all of the silver coins brought to him to be melted down and made into useful objects such as the teapot in the painting.

John Singleton Copley, who painted the portrait of Revere, was the most important American artist of the colonial period. Copley painted what he saw, and in Paul Revere he saw a man of character and strength.

Paul Revere is most famous for his midnight ride to warn the Minutemen soldiers to unite against the British. But he also used his silversmith trade for patriotic causes, making coins for the Continental Army (of which he was an officer) and producing an engraving of the Boston Massacre. This print, which shows British soldiers firing on a Boston mob in 1770, became the best known protest picture of the Revolutionary period.

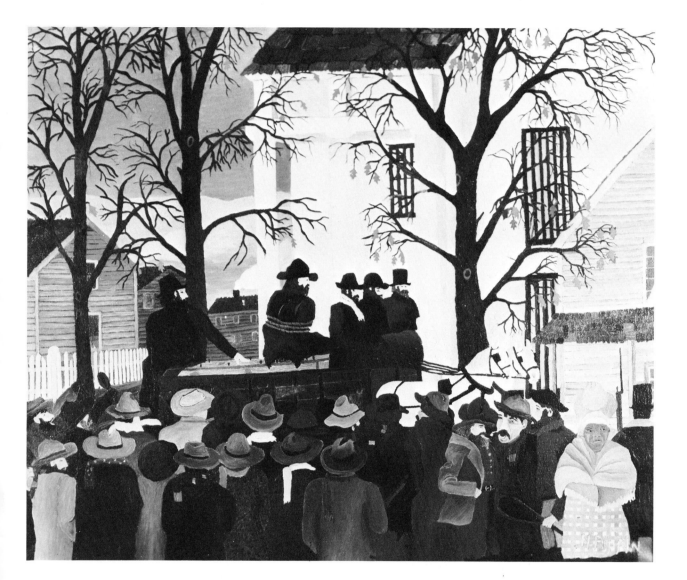

John Brown Going to His Hanging (1942) by Horace Pippin (1888-1946); Pennsylvania Academy of Fine Art, Philadelphia.

This portrait of John Brown reveals the artist's admiration for one of the leaders of the antislavery movement in the period before the Civil War.

John Brown wanted to end the practice of slavery in the United States. His plan was to set up a community of slaves who had fled from their owners. He hoped to establish this community in the Appalachian Mountains, and from there to fight the states where slavery was legal. He needed guns and ammunition to do this. On the night of October 16, 1859, Brown led 18 men to the arsenal (where weapons were stored) in Harper's Ferry, West Virginia. The group captured the arsenal but did not escape. They held out for two days before they were overpowered and arrested. Brown was tried, found guilty, and hanged. The strong statements he made against slavery in his last days created great sympathy for him among people who agreed with his cause.

John Brown Going to His Hanging was painted by Horace Pippin, a self-taught black artist. It is a simple, primitive painting of John Brown seated in his own coffin on the way to the gallows. The crowd of people form dark shapes against the light background, suggesting a mood of quiet sadness. But the stillness of the painting is broken by the finger-like branches of the trees, which seem to be moving across the cold sky. This picture expresses John Brown's spirit of determination, which still inspires many people today. Even though he is dead, "his soul goes marching on."

The movement to organize workers into unions has been a slow and painful one in this country. The purpose of a union is to strengthen the requests of employees for better working conditions and improved wages. In a union, workers act as a group, rather than as individuals. When a union and the employers discuss benefits for the workers, the process is called collective bargaining. But before a union can bargain, it must convince an employer to accept the group as a representative of the individual members.

Philip Evergood's oil painting *American Tragedy* shows how violent the struggle to get an employer to accept a union could be during the labor movement's formative years. It depicts a bloody event that occurred on Memorial Day of 1937 in Gary, Indiana.

More than one thousand workers from the Republic Steel plant went to a meeting of the union—which was not approved by the company—and then marched to the gates of the factory. They were greeted unexpectedly by a large group of city police. The police threw tear gas bombs into the crowd and charged on the marchers, swinging billy clubs and firing guns. Ten marchers were killed and 100 were wounded. The others fled with the police running after them.

Philip Evergood, who had participated in a protest march in the 1930s himself and had been arrested and jailed, was sympathetic to the workers. He shows his outrage in this painting.

American Tragedy (1937) by Philip Evergood (1901-); collection of Mrs. Armand G. Erpf, New York; photograph by Geoffrey Clements.

Evergood used newspaper photographs, written accounts, and his own imagination in creating this painting. In the center stand a worker and his wife. She wears a spring-like green dress and carries a stick as her only weapon. She and her husband show us the resistance of all the workers, and their faces express their strong feelings. Violent conflict rages around the man and his wife. By painting drab houses and factories in the background, Evergood suggests the reasons for the workers' dissatisfaction. His painting is more than just the recording of a specific event. It is a general statement about all social strife.

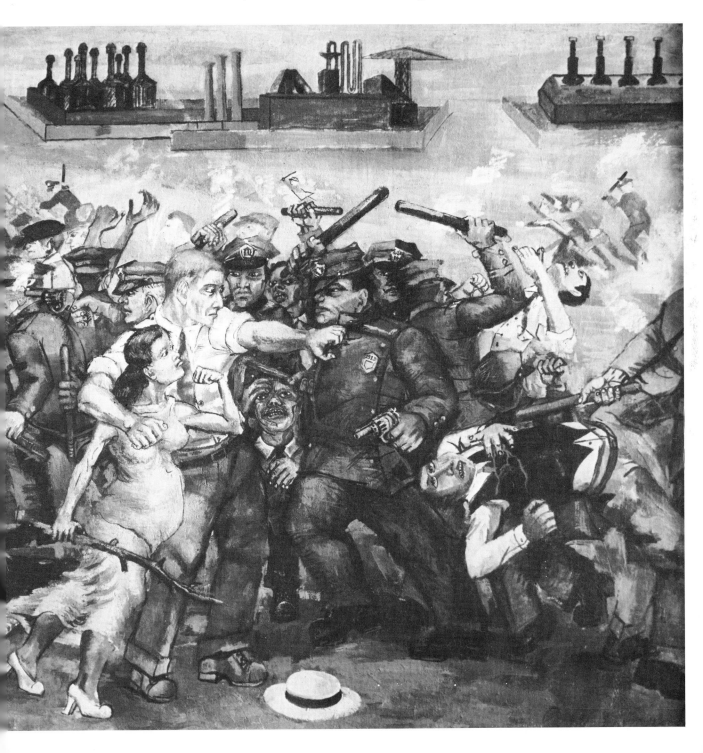

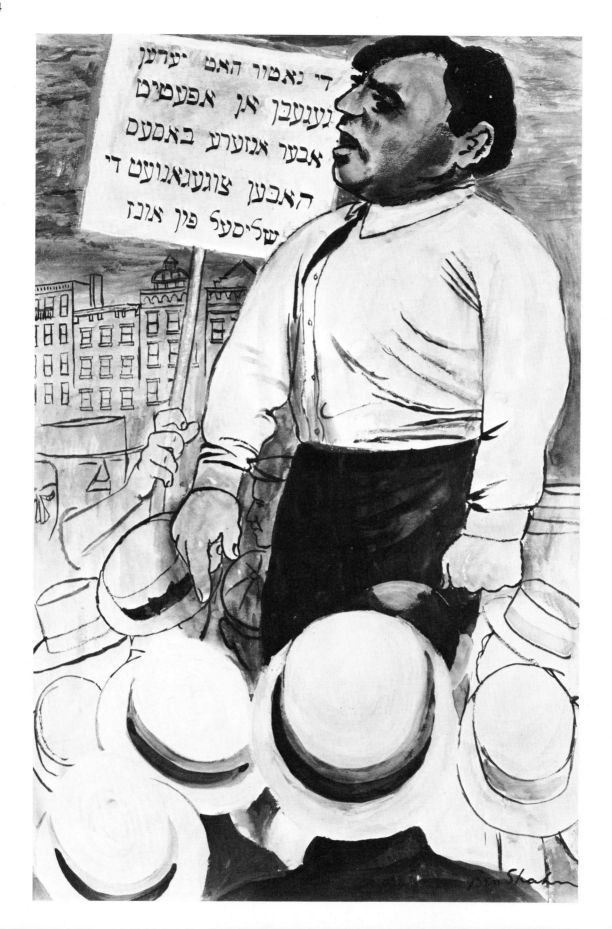

East Side Soap Box (1936) by Ben Shahn (1898-1969): Kennedy Galleries, Inc., New York.

Politician Fiorello LaGuardia and artist Ben Shahn had a lot in common. Both were concerned about the oppressed and the defenseless—children, the poor, and the foreign born. Both fought for social justice: La-Guardia was the non-partisan, reform mayor of New York City, and Shahn was an artist who portrayed the suffering of the poor with great sympathy.

In *East Side Soap Box*, Shahn uses several sketchy lines to show the excitement and strength of LaGuardia's personality as he campaigned for his second term as mayor. Like most of Shahn's work, it tells a simple story—as the artist saw and interpreted it.

Fiorello LaGuardia was known affectionately as "Little Flower," from his first name. He was short and exuberant, and had rumpled black hair and glistening eyes. Shahn painted LaGuardia as he often appeared in public, wearing no jacket and looking like any other working man. The face is forceful and not especially good looking, but that's the way it was. "Little Flower" is surrounded by the people he loved to address, and the sign tells us who some of them were.

Shahn included the sign—written in Yiddish—to indicate LaGuardia's fluency in seven languages: English, Italian, German, Yiddish, Croatian, French, and Spanish. The people who spoke those languages, the ethnic groups who came to New York seeking a better life, provided LaGuardia with much of his support.

"Nature gave every human being an appetite, but our bosses stole the key from us," the sign says. It means that the new immigrants were denied political office by the "bosses" who ran New York. LaGuardia was not a boss, and through him New York's many nationalities gained a voice in their government.

LaGuardia was a very unusual man who always kept in touch with the people. He roamed the city at night, appearing suddenly at the head of a police raiding party or even riding on the city fire engines. Once, during a newspaper strike, he read the comic strips over the radio to the children of New York.

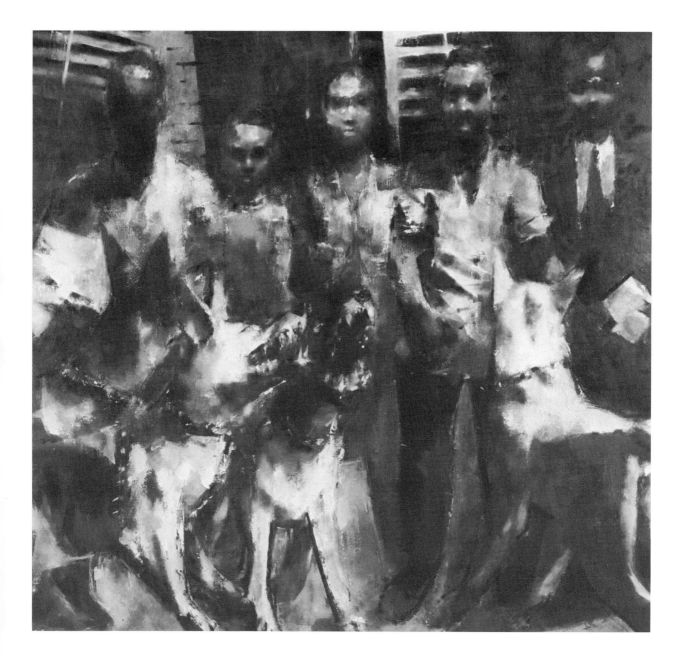

Birmingham, 1963 by Jack Levine (1915-); collection of Mr. and Mrs. Charles Benton, Evanston, Illinois.

In April 1963 the Reverend Martin Luther King, Jr., chose Birmingham, Alabama, for a campaign of sit-ins and demonstrations. He chose Birmingham because it was, in his words, "the most thoroughly segregated big city in the U.S." Birmingham required the segregation of all white and black people by force of law.

The demonstrators marched day after day under the slogan of "Freedom Now," calling for the desegregation of public facilities. The city police responded by arresting King and trying to disperse the demonstrators, which included some children, with police clubs, fire hoses, dogs, armored cars, and mass arrests. On May 2, over 500 demonstrators were jailed.

Front-page newspaper photographs of the police tactics shocked people across the country and set off racial protests in other cities.

Jack Levine, an artist who often takes social injustice as the theme of his work, painted *Birmingham, 1963* to show the bravery and courage of the black people against the police and their dogs. The faces of the people show their dedication to the cause of civil rights. Everything is blurred, as if the artist was horrified at what he saw. Specks of glistening white light dart like lightning over the surface of the painting, suggesting an atmosphere charged with hostility. Levine makes it clear in this picture that he is on the side of the protestors.

Fritz Scholder is considered the leader of the new Indian art movement, which has grown out of a larger movement to gain greater recognition of the rights of American Indians. The son of a half-Indian teacher, Scholder lives in Sante Fe, New Mexico, where he was formerly on the staff of the Institute of American Indian Arts.

Scholder says that his main goal as an artist is to paint Indians as he sees them today, not as they were before the white man came. But in his future works he also hopes to convey the dignity of Indians of former times, who have usually been painted as losers in battles with the white man. He also hopes through his paintings to show Indian humor. Sometimes Scholder's Indians are ugly, but he believes that ugliness is beauty when it is truth.

In *American Indian*, an oil painting, Scholder presents an Indian wrapped up in an American flag. The expression on the Indian's face tells us that he is not too happy about having the flag draped around him, even though he is smiling. The Indian may be thinking that he is proud to be an American, as symbolized by the flag, but he is also proud to be an Indian, so he holds a tomahawk and wears a feather in his hair. His smile tells us that it is hard to be both an American and an Indian at once, but that he is trying.

Scholder is saying in this painting that Indians should be regarded with dignity and respect and given the freedom to determine the way they want to live in America.

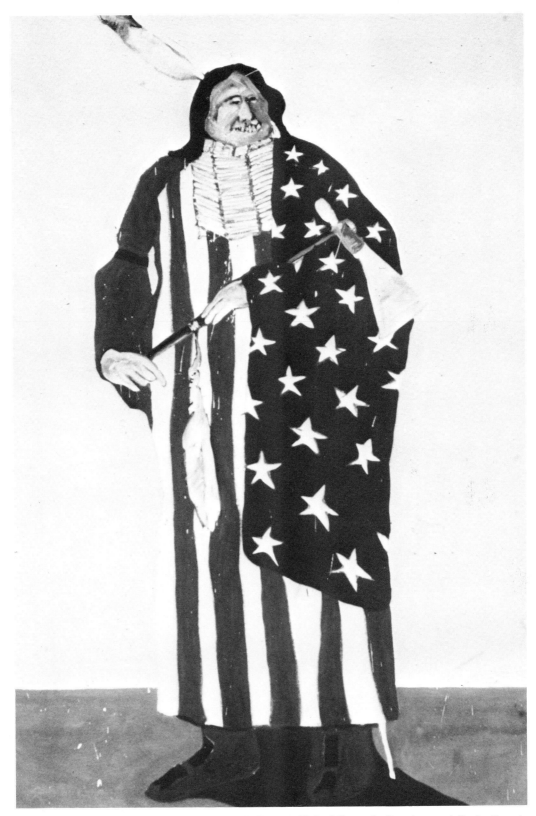

American Indian (1970) by Fritz Scholder (1937-); United States Indian Arts and Crafts Board, Washington, D.C.

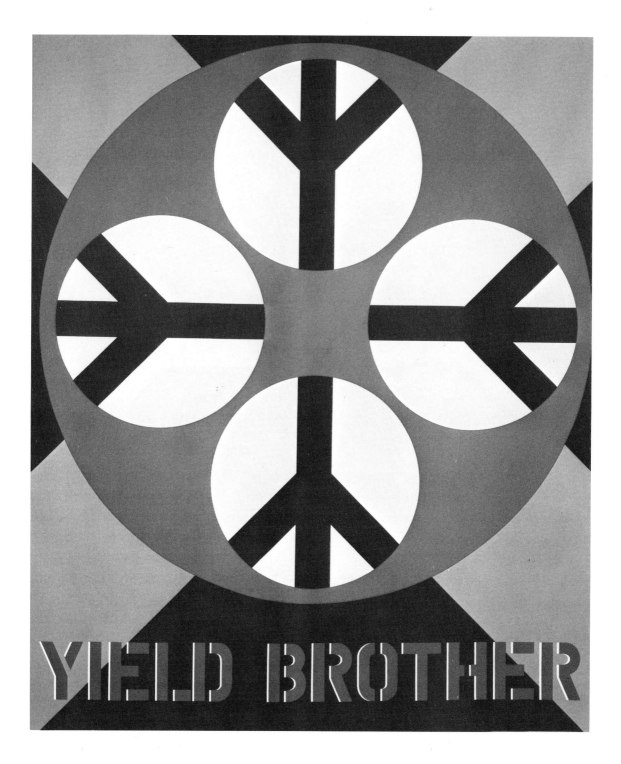

The peace sign has the same meaning to people all over the world. It was first used in England in 1958, when it was carried in a march led by the pacifist and philosopher Bertrand Russell. The purpose of the march was to urge nations not to use nuclear bombs.

The design of the peace symbol is the combination of semaphore signals for the letters *n* and *d*, which stand for nuclear disarmament. The semaphore system is a system of signals used to send messages between two people. Each person holds two flags and moves them into various positions that represent letters of the alphabet. To make the letter *d*, one flag is held straight up and the other straight down. To make the letter *n*, the flags are held out from the body, one at each side, at about a 45-degree angle.

Robert Indiana first created *Yield Brother* as a painting, in 1962. He later copied it to be reproduced as a poster. The artist used four peace signs to create a design, but *Yield Brother* is more than a simple decoration. With the message printed along the bottom of the poster, it becomes a strong plea for peace. Indiana's use of the word "yield" comes from the road sign. "Brother" suggests worldwide friendship. In other words, he is saying that if we are ever to stop war and have peace, we must learn how to understand each other.

Yield Brother (1962) by Robert Indiana (1928-); Bertrand Russell Peace Foundation, London, England; photograph courtesy Multiples, Inc., New York.

the author

Joan Adams Mondale, who is the wife of Walter F. Mondale, Minnesota's senior Senator, has been involved in the world of politics for many years. She has been active in the Democratic-Farmer-Labor party since 1960, having served as a local ward chairwoman and in several other capacities. In Washington, she is a member of the board of the Woman's National Democratic Club and was its legislative program chairwoman for two years.

Mrs. Mondale's interest in art has been lifelong. After graduation from Macalester College with a major in history and a minor in art, Mrs. Mondale served as an Assistant Slide Librarian at the Boston Museum of Fine Arts for a year. For the next four years, she worked as an Assistant in Education at the Minneapolis Institute of Arts, where she gave guided tours and lectures to children and adults. In Washington, Mrs. Mondale gives weekly guided tours at the National Gallery of Art.

The Mondales live in the District of Columbia. They have three children: Teddy, Eleanor Jane, and William.

77